IMAGES
of America

KENTUCKY'S
GREEN RIVER

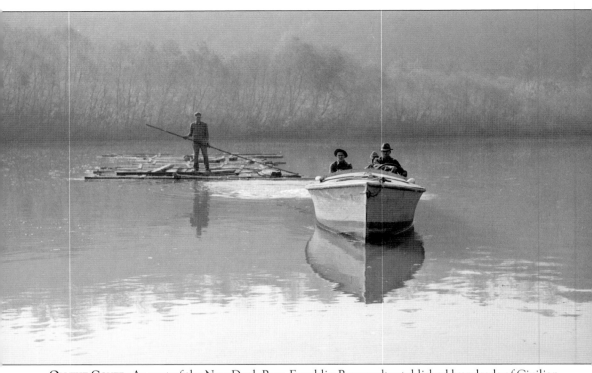

ON THE COVER: As part of the New Deal, Pres. Franklin Roosevelt established hundreds of Civilian Conservation Corps (CCC) camps across the United States to aid in the building of national parks, wildlife refuges, and forests. Four CCC camps were located on land that would become Mammoth Cave National Park in 1941. This photograph shows a CCC crew towing logs that were used to build tourist cabins in the park in 1936. (Open Parks Network.)

IMAGES
of America

KENTUCKY'S
GREEN RIVER

Richard Hines and Pam Hines

ARCADIA
PUBLISHING

Published by Arcadia Publishing
Charleston, South Carolina

Printed in the United States of America

Library of Congress Control Number: 2023931733

For all general information, please contact Arcadia Publishing:
Telephone 843-853-2070
Fax 843-853-0044
E-mail sales@arcadiapublishing.com
For customer service and orders:
Toll-Free 1-888-313-2665

Visit us on the Internet at www.arcadiapublishing.com

We are dedicating Kentucky's Green River *to my grandparents L.J. and Fairy Hines, who lived in Woodbury along the Green River; to Ida Edwards, who took me to the Rochester dam on many occasions so I could fish in the river; and to Tommy Hines Sr., who began my swimming lessons below Woodbury Dam and who gave me the love of the outdoors when he took me on quail and squirrel hunting trips along the Green River. To my stepfather, Ambrose Reid, who instilled a love of photography I still use today, and my mother, Vivian Reid, who gave me early guidance in writing.*
—Richard Hines

To Richard, my husband of 44 years, who taught me how to appreciate Kentucky's outdoors when we took our boys camping, fishing, and canoeing on the Green River. I also enjoyed learning about the river on our trips to Hines family reunions in Woodbury, where I heard so many stories about life along this great river that I am now sharing with you.
—Pam Hines

Contents

ACKNOWLEDGMENTS

Over the past year, we traveled extensively across 15 counties to obtain information about the Green River. We met numerous people who helped by not only providing material but referring us to local experts, and we are extremely grateful to those of you who took time to answer phone calls and respond to our emails, all of which helped make *Kentucky's Green River* possible. Phil Refbord assisted with document searches. Tommy Hines, director of Green River Museum in Woodbury, and Tommy Hines Sr. assisted with editing. Nancy Richey with Western Kentucky University Library Special Collections worked extensively to help us retrieve photographs and documents from the collections on the Green River.

Various historical organizations and government agencies and staff from across the region provided extensive time and materials over the course of this project. These include Kevin Welch and the Cincinnati & Hamilton County Library, Jennifer Greene with David L. Rice Library at the University of Southern Indiana, Kyle Stearns with Evansville Vanderpool County Library, Carolyn Short and Marcia Lenz with Hart County Historical Society, Hopkins County Genealogical Society, Green River Museum, Holly Johnson with Livermore's Facebook group, Terry Langford with Mammoth Cave National Park Museum, Open Parks Network, Vicki Ventura with McLean County History Museum, Jerrica Harris and the Metcalfe County Library, Lisa Guerre, William S. Webb with Museum of Anthropology, Maureen Hill with National Archives at Atlanta, Tennessee Valley Authority records at the National Archives, Helen McKeown with Ohio County Museum, Andrea Davis, US Army Corps of Engineers Green River Lake Project, Sarah Coblentz at University of Kentucky Library Special Collections, Katelyn C. Newton with the US Army Corps of Engineers (Louisville District), and Stacy Hayden with the US Fish and Wildlife Service.

The individuals who assisted us and provided photographs include Courtlann Atkinson, Ronnie Corbin, Frank Coffman, Bryon Crawford, Eric Cummins, Barry Duvall, Grady Ebelhar, Billy Fudge, Pipes Gaines, Buck Goode, Betty Gorin, Ed Huffman, Mark Maddox, Monte McGregor, Marilann Melton, Paul Moore, Willard Parnell, James Polson, Richard Roney, Rob Simbeck, Larry Smith, Norman Warnell, Michael Wiser, and Alan Vance.

INTRODUCTION

The Green River begins its 384-mile trip through Kentucky at Kings Mountain in Lincoln County at an elevation of 1,050 feet, gradually falling to 337 feet at its confluence with the Ohio River in Henderson County. The largest of 12 watersheds in Kentucky, the river crosses 15 counties and three physiographic regions, draining 9,230 square miles across 32 counties in Kentucky and three counties in Tennessee.

Historical accounts show that the Green River was named for Revolutionary War general Nathaniel Greene. In *A History of Muhlenberg County*, Otto Rothert mentions that early German immigrants in Muhlenberg County referred to this river as the Grube, a German word for deep ditch, and that the river had an intense emerald green color. Because of the large number of bison in the area, it was called Buffalo River for a time.

The Green River is often referred to as the "deepest little river in America" or the "deepest river in the world," but it appears this folklore is mistaken. While some stretches of the Green are extraordinarily deep due to sinkholes and springs, it does not rank among the top 10 deepest rivers in the United States.

The first inhabitants of the valley began occupying the area around 8,000 or 9,000 years ago. Indigenous peoples developed settlements along the river, which has the largest number of known archaeological sites in Kentucky. One resource the river provided was a large population of freshwater mussels. These mollusks were easily harvested in shoals along the river and resulted in piles of shells called middens, many of which remain visible today.

French explorers began visiting the area around the mid-1700s, but it was not until 1770 that English immigrants began entering the region. Prior to the Revolutionary War, permanent settling in Kentucky was restricted by the British. Although the land was granted to the British at the end of the French and Indian War, Britain's royal proclamation of 1763 restricted colonists from moving west of the Appalachian Mountains. Regardless, hunters, trappers, and explorers had already begun to venture into Kentucky to harvest abundant the fur and hides.

With the end of the Revolutionary War, settlers from Virginia began moving into Kentucky. The land was free to them except for all land south of the Green River, which was reserved for Revolutionary War veterans, with acreage allotted according to their ranks. In 1781, Capt. Abraham Lincoln (President Lincoln's grandfather) received an 800-acre land warrant along the river in present-day Casey County near Middleburg for his service in the Continental Army. Captain Lincoln was among hundreds of Revolutionary War veterans who settled the Green River country.

As settlers arrived, they found most land south of the river treeless barrens, or prairies, with only scattered groves of trees, while north of the Green, dense hardwood forests and canebrakes were found. Massive trees grew along the entire floodplain, providing habitat for eastern turkeys, black bear, red wolves, and white-tailed deer. Deer numbers were much lower than at present due to less suitable habitat in the dense forests. The most prominent large game animals were eastern elk and bison.

During the fall, elk and bison made seasonal migrations from the barrens south of the river into the forests to the north to feed on American chestnut and other hardwood mast. One river crossing, near the present-day location of Rochester, was described by Native Americans as Big Falls. There was a salt lick near here, and even into the early 1900s, a portion of the six-foot-deep trail leading from the falls into the barrens of present-day Logan and Christian Counties was still visible in Muhlenberg County.

Birds such as Carolina parakeets fed on cocklebur that grew along the mud-lined riverbanks in late summer. The impressive ivory-billed woodpecker that John James Audubon often wrote about was seen feeding on insect larvae in dying trees throughout the virgin bottomland forests along the river. Massive flocks of passenger pigeons—estimated by Audubon to number in the billions—fed along the river. Today, these three species once common along the Green River are extinct, although the last bison sighted in Kentucky was seen along the upper Green River.

The earliest towns that appeared along the Green River were at game crossings. The "big buffalo crossing" would later become Munfordville, and crossings used by Indigenous peoples for thousands of years became routes for settlers, and eventually, today's highway crossings. Another significant crossing was at Greensburg, called the Great Warrior Trail; it connected Native American towns near present-day Chattanooga with the falls of the Ohio River at Louisville.

Although settlements were becoming more permanent in the area around 1782, Munfordville was still referred to as the edge of civilization, with only a handful of cabins. There was strong resistance to the new arrivals from local Indigenous peoples, and for many years, most of the river valley was considered unsafe. The Indigenous tribes were primarily Shawnee to the north and Cherokee to the south of the river.

As farms were established, they began producing not only what they needed but surplus products as well. Flatboats were the safest and most economical way to ship this produce out of the valley, including fur, hides, whiskey, and ginseng. During the late 1700s and early 1800s, flatboats could only travel downstream, so when they arrived at their destination, the lumber used to build them was sold along with the agricultural products they had carried.

Early publications mention navigable waters, but often this simply meant a boat could float along the river from the upper sections during high water. Allan Montgomery from Greensburg was one of the first to ship bacon and corn downriver. He soon discovered that lime was in short supply, and began manufacturing it in pits along the river and selling it for a premium in New Orleans.

In the 18th and 19th centuries a flatboat trip from Greensburg to New Orleans was a perilous trip taking several months, with many boatmen never returning. After flatboaters sold their boats and products, they walked back along the Natchez Trace to Nashville and into Kentucky. Allan Montgomery made this trip every year for 40 years. Many times, several boats would follow each other until they reached the Ohio River, where they would lash together for increased security against pirates and Indians, who were numerous especially near the mouth of the Green. Where the Green joined the Ohio there was a low-water crossing referred to as a lawless area occupied by "rogues and land pirates." Helen Crocker added that "the Chickasaws jealously guarded the entrance to Green River."

Timber was one of the most sought-after products in the Green River Valley, with billions of board feet waiting to be harvested. Each summer, loggers would cut and move logs to the riverbank, where they were assembled into rafts. The rafts would lie in wait until high water, or a "tide," came to float the logs, typically during winter or early spring.

As the rafts were floated, several men would board them, taking sufficient provisions for the multiweek trip. Experienced raftsmen would steer the raft during the day and tie up overnight. It was a dangerous trip, as each raft had to cross the numerous dams and avoid snags and other debris until they reached the lumber markets in Evansville. The hundreds of log rafts sent down the Green River helped make Evansville a world-renowned hardwood center. Other towns, such as Livermore, also developed into wood manufacturing centers. Livermore became famous for manufactured chairs. Maurice Hines said that when he was a young boy, he saw one of the last log rafts at Woodbury in the late 1920s or early 1930s.

Hundreds of paddlewheel steamers moved freight and passengers from the river's mouth at Henderson as far up as Mammoth Cave for over 100 years. Helen Crocker stated that the first steamboat to reach Bowling Green (by way of the Barren River) was the *United States* on January 26, 1828. This was the beginning of one of the most glorious periods in Green River's history.

One of the most prominent men to introduce steamboats to the Green River was James R. Skiles, who spent a fortune promoting the improvement of navigation along the river. The town

of Rumsey, originally in Muhlenberg County, was said to have been named after James Rumsey, who invented the first steam engine capable of propelling a boat 20 years before Robert Fulton's patent. One of the first steamboats built at Rumsey to operate on the Green River was the *Lucy Wing*, named after a Greenville girl.

By the early 1800s, Congress had recognized the importance of the river and begun appropriating funds to improve river conditions. In 1836, $250,000 was spent on the Green and Barren Rivers to improve stream navigability. Over the next 50 years, locks and dams were constructed on the Green and its tributaries, the Rough and Barren Rivers.

The steamboat industry grew rapidly. Beyond goods, steamboats also transported passengers, some of whom bought tickets just to ride upstream and view the "Green River country." W.P. Greene said of the river, "it is the most interesting [river] on the American Continent . . . with its vast timberlands, bountiful coal, and iron with scenery that will complete with that of the Rhine or Hudson." Steamboats also brought entertainment and photographers (along with their floating studios); entire families would come to the local landing to have pictures taken and watch plays.

During severely cold winters, travel halted along the rivers, and the Green was an important safe harbor for Ohio riverboats. Due to the large number of springs in the Green, it typically did not freeze as quickly as the Ohio, and steamers would pull into the Green with a minimal crew and supplies to wait out the cold weather, avoiding the large ice floes known to wreck steamboats. The Green River froze several times, once in 1917–1918, when ice tied up the river for 40 days. In 1935–1936, river traffic was suspended for 23 days, and again in 1939–1940, which forced residents in Morgantown to take sleds to Bowling Green to obtain food and supplies.

As river traffic increased, numerous communities arose along the river. Paradise, Birk City, Skilesville, South Carrolton, and Rochester were ports with wharf facilities where goods were unloaded and hauled to nearby towns. By 1899, Rochester had over 1,000 residents. Woodbury had stores, a bank, a doctor's office, and hotels; however, as the river traffic disappeared, so did these small towns, which are now merely remnants of what they once were.

Railroads, the nemesis of the steamboat industry, also developed quickly, competing with steamers for passengers and freight. Steamboats did hang on for a short time, providing touring packages to Mammoth Cave. The last two packet steamboats (passenger boats that operated between two points on a regular basis) on the Green River were the *Bowling Green* and the *Evansville*. In 1920, the *Bowling Green* sank at South Carrollton, while the *Evansville* burned at the Bowling Green wharf in July 1931. It was the last of the Green River fleet, and the 1931 fire essentially closed the chapter on Green River's steamboat era, which had lasted for just over a century.

Steam-powered towboats did continue towing barges of coal, lumber, and asphalt out of the valley. Minerals have always been important in the Green River Valley, and the first load of coal barged out was mined at McLean on the Mud River and shipped to Evansville.

By 1954, Congress had appropriated $4.2 million to improve Locks 1 and 2 for the purpose of accessing the lower 100 miles of the Green River, which held some of the largest coal reserves in the nation. Within five miles of the river on both sides were an estimated 1,588,490,000 tons of coal. The coal was seen as a critical ingredient in the nation's progress, and improving the locks would aid in its transportation.

The Green River has flooded on numerous occasions, including the 1884 and 1913 floods, but the largest to date was the 1937 flood, which surpassed all prior floods during the previous 175 years. From 1961 to 1968, the US Army Corps of Engineers constructed flood control dams on the Barren, Rough, Nolin, and Green Rivers. Only one dam, which had been planned at Mining City in Butler County, was not constructed.

Today, towboats continue moving cargo through the lower 100 miles of the river. In 2021, over two million tons were moved through Lock 1, while about half a million tons moved through Lock 2. The Green River remains an important transportation corridor.

The upper Green River is one of the most biologically diverse rivers in the United States. It is home to 42 endemic species (meaning these species exist nowhere else in the world) and provides habitat for over 150 species of fish and 70 species of freshwater mussels. With the decline of

commercial river traffic on the upper segment of the Green, three of the original locks and dams are in the process of being removed to help restore the river's original flow, further protecting rare aquatic species while improving recreational opportunities for those who enjoy life along the river.

Few North American rivers can boast of both diversity of species and public land. The Green is home to the Green River National Wildlife Refuge, Green River State Forest, Sloughs Wildlife Management Area, Mammoth Cave National Park, Green River State Park, Green River Wildlife Management Area, and numerous historical sites, including Tebbs Bend and the Battle of Munfordville site. Peabody Coal Company, which once featured the world's largest shovel at its strip mine, is now the Peabody Wildlife Management Area, one of the larger wildlife management areas managed by the Kentucky Department of Fish and Wildlife.

The segment of the Green River that traverses Mammoth Cave National Park has been designated an Outstanding Resource Water and a Kentucky Wild River.

Kentucky's Green River will take the reader from the mouth of the river where it meets the Ohio River at river mile 0.0 to the river's source, a wet-weather spring flowing from a small bluff on Kings Mountain in Lincoln County.

One

LOCKS, DAMS, AND THE FLEET

Prior to the first dam being constructed in 1838, the only mode of transportation on the Green River was flatboats, which were constructed and launched during high water to move cargo downriver. After months of river travel, boatmen would return on foot, but with the construction of dams to provide sufficient slack water, steamboats were able to move upstream during all months of the year.

There were once six locks and dams on the Green, as well as one lock and dam on both the Rough and Barren Rivers. With these dams, boats were able to reach Brownsville and Mammoth Cave. Efforts were made in 1895 to improve navigation past the Little Barren River, thus providing sufficient water to Greensburg, but the bill failed in Congress.

A large fleet of steamboats operated on the river into the early 1900s, with vessels ranging from steamboats to towboats. Steam-powered towboats continued operating on the Green until 1947, when the last steam towboat, the *New Hanover*, was sold. Around the same time, diesel towboats were beginning to tow barges of asphalt, coal, and grain. By 1951, asphalt mining became unfeasible, and with little or no river traffic, Lock 6 was closed.

At the start of the 1960s, all the dams on the upper portion of the river were falling into disrepair, and when Dam 4 at Woodbury failed in 1965, all river traffic to Bowling Green and Mammoth Cave ended. Today, only Lock and Dam 1 and 2 remain in operation.

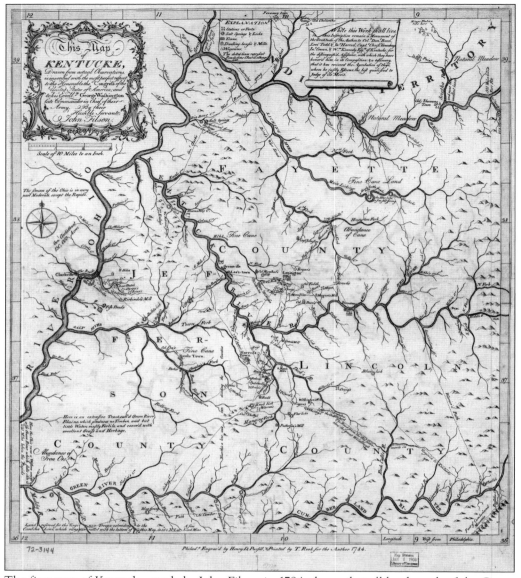

The first map of Kentucky, made by John Filson in 1784, shows that all land south of the Green River was "reserved for the Virginia Troops extending to the Carolina Line." Today, this is the Tennessee border. Each soldier who served in the Revolutionary War received land patents as payment. Some opted to remain in Virginia and sold their patents, but many did come to Kentucky. (Western Kentucky University Special Collections.)

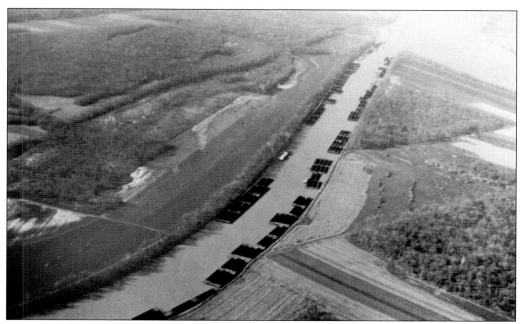

Shown above is the Green River fleeting area at its confluence with the Ohio River in Henderson County. Because towboats on the Green can only move two barges wide and two barges long (called a two by two tow), barges are temporarily moored at the fleeting area until they can be reassembled into larger fleets four barges wide and five long (a four by five tow) for shipping on the Ohio and Mississippi Rivers. Below, two towboats meet in the Green River. The loaded, downbound tow (bottom) has the right of way, while the empty, upbound tow pulls over. The Green River is narrow, which requires towboat pilots to stay in touch by radio to make passing arrangements. (Both, US Army Corps of Engineers.)

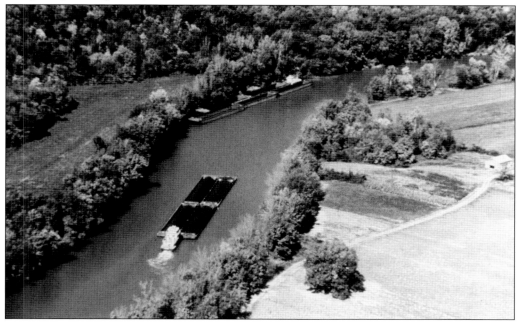

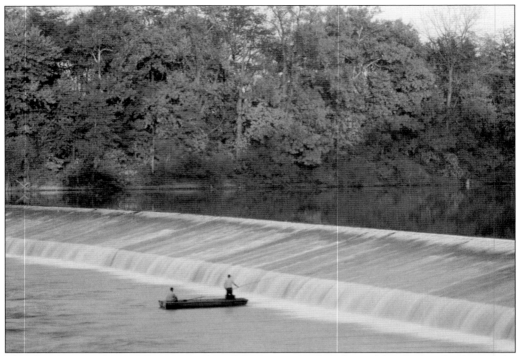

The above image shows fishing at Lock and Dam 1 in 1946. Fish would gather at the foot of the dams along the river, so it was common for fishermen to anchor under the dam during low water conditions. Below is an aerial view of Lock and Dam 1. (Above, National Archives; below, US Army Corps of Engineers.)

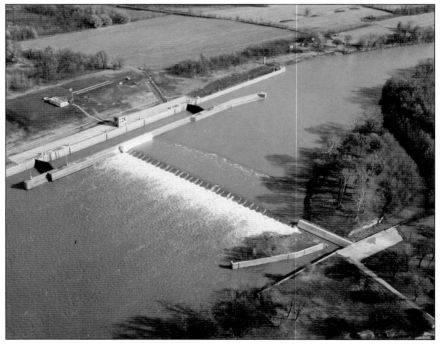

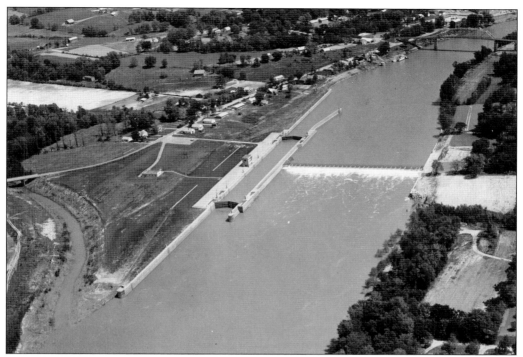

Lock and Dam 2 is seen here, at Calhoun and Rumsey. The image above shows how the dam maintains Pool 2 (top right) at a consistent depth of slack water needed for barge traffic. The lock chamber at center raises or lowers boats into or out of the upper pool. Below, a towboat with barges clears Lock 2 in 1973 after it has been lowered from Pool 2 into Pool 1. The towboat will move these barges of coal to the fleeting area at the mouth of the Green River. All lock chambers are built for a set number of standard-size barges. (Both, US Army Corps of Engineers.)

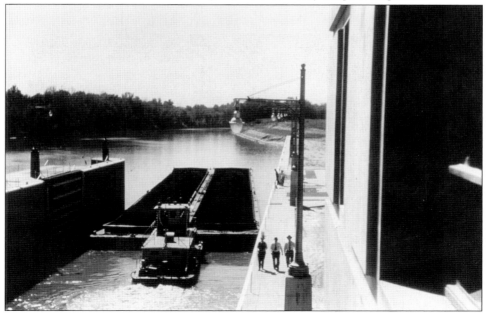

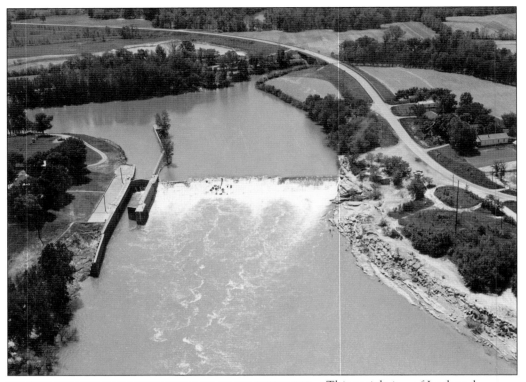

This aerial view of Lock and Dam 3 at Rochester is from May 1964. In June of the same year, the *Belle of Louisville* made a trip to Rochester Dam carrying over 1,100 passengers including many famous Green River boat captains and crew members. It had been over 30 years since the last paddle wheeler had traveled on the Green. (US Army Corps of Engineers.)

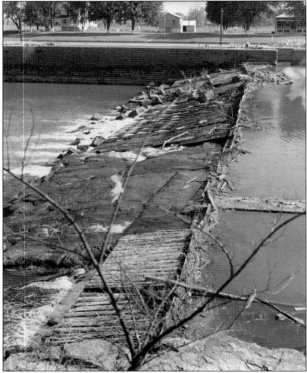

By the 1970s, maintenance on Lock and Dam 3 had begun to falter, as shown by the log cribbing beginning to disintegrate. As the cribbing fell away, it revealed the original rock falls that Native Americans had called Big Falls. When the lock was built in 1838, rock was excavated from the east side of the river to allow boats to lock through the dam. (Photograph by Ambrose Reid.)

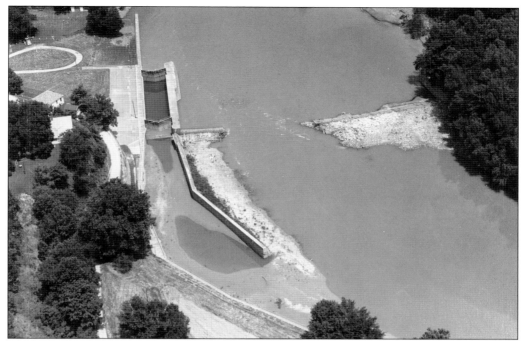

This view of Lock and Dam 4 at Woodbury is from three years after the dam failed in 1965, closing all river traffic because water levels were too low for towboats to operate. One towboat owned by Tommy Melton and James Hines waited in the Barren River until flood waters were high enough to navigate over the breached dam. (US Army Corps of Engineers.)

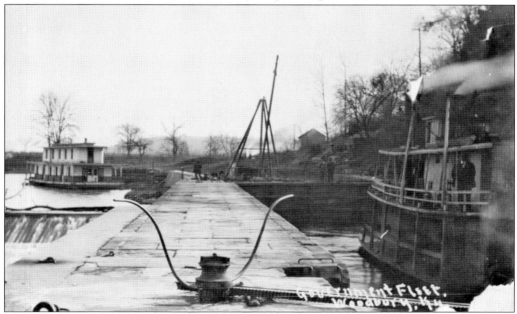

The US Army Corps of Engineers fleet assigned to the Green and Barren Rivers was maintained at Woodbury. The quarter boat on the left is where workers lived while working on the river. (Green River Museum, George Dabbs Collection.)

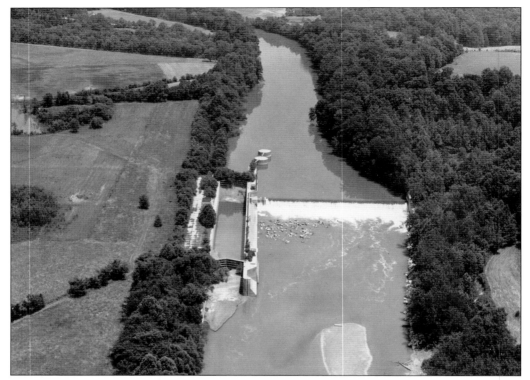

In 1968, three years after operations were closed on Lock and Dam 5, trees have already begun growing in the lock chamber. Built in 1900 and improved in 1934 so boats could be lifted 15.2 feet above Pool 4, the lock was abandoned when Dam 4 at Woodbury failed. The entire lock and dam were removed in 2022, restoring the river to its original flow. (US Army Corps of Engineers.)

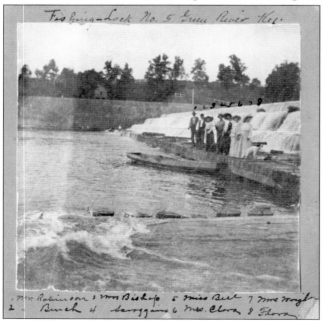

Many guests who stayed at nearby Massey Springs Hotel would fish at Lock and Dam 5. The hotel was a regular stop and was noted as one of the most popular resorts in the south. Massey Springs visitors came primarily for the supposed healing powers of the mineral water, but the hotel also offered fabulous meals, dancing, swimming, bowling, fishing, and squirrel hunting in the nearby woods. (Western Kentucky University Special Collections.)

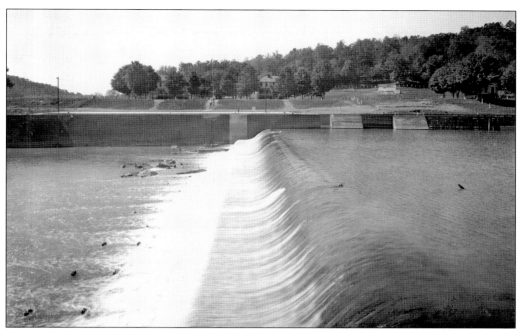

In 1939, Lock and Dam 6 was the newest navigation structure, providing slack water to Mammoth Cave and upstream in the Nolin River to Kyrock. This was the uppermost pool and the last segment where boats could travel up the Green River. Operation was abandoned in 1951 because of a lack of river traffic. An environmental study in 2004 determined that Lock and Dam 3, 4, 5, and 6 were no longer usable. Below, an excavator is shown removing the concrete structure at Dam 6 in 2019. In the time since this photograph was taken, two other dams have been removed. After concrete and steel were removed, the bottom of the river was restored to its original gradient. (Above, US Army Corps of Engineers; below, photograph by Richard Hines.)

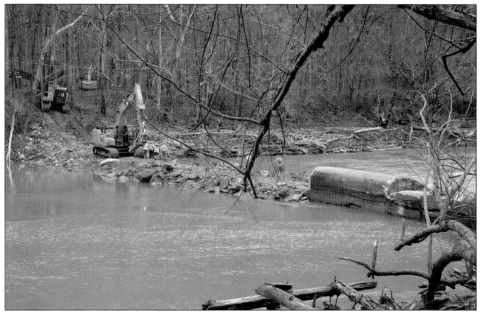

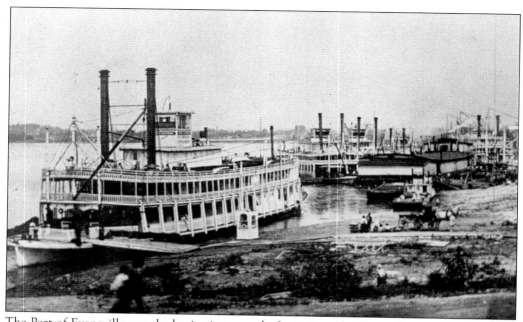

The Port of Evansville was the beginning or end of trips into the Green River area. This image shows the steamer *Bowling Green* on the riverfront at the Evansville landing in the process of being loaded, presumably for a trip to Bowling Green. With stops at each port along the way, the trip would have taken several days to complete. (University of Kentucky Library.)

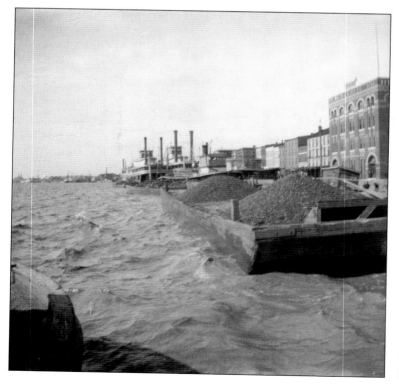

These barges are moored at Evansville. Early barges were built of wood with reinforced steel corners. Barges have changed little since they were developed from a craft called a scow—a flat-bottomed, flat-sided vessel that could operate in shallow water. Today, a loaded barge requires a nine-foot-deep channel. The tow-barge system used today was developed during the Civil War. (University of Southern Indiana.)

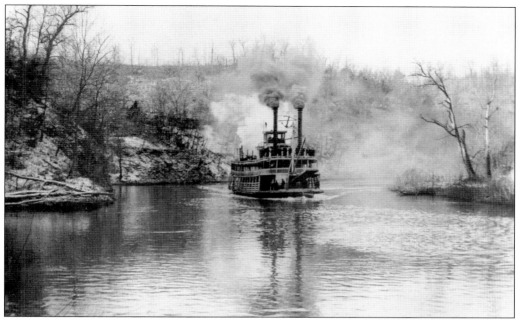

George Dabbs, one of the most famous photographers in Green River country, created this classic 1906 photograph of the steamer *Chaperon* in Green River's "Turn Hole," which was wide enough for steamers to turn around in so they could reverse course in the river. (Cincinnati and Hamilton County Library.)

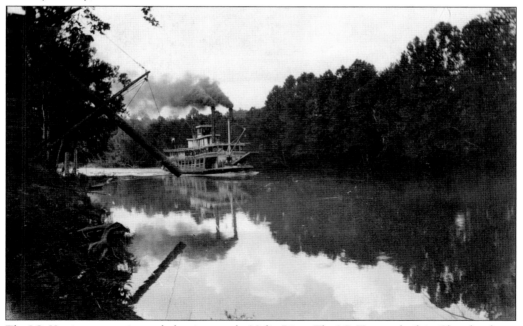

The *J.C. Kerr* is seen passing asphalt mines on the Nolin River. The *J.C. Kerr* was built in Chambersburg, Ohio, in 1884, and operated on the Ohio River until 1892, when it was moved to the Green River. In 1904, it began operating from Bowling Green to Mammoth Cave, but was later overhauled, remodeled, and given the name *Chaperon*. (University of Kentucky Library Special Collections.)

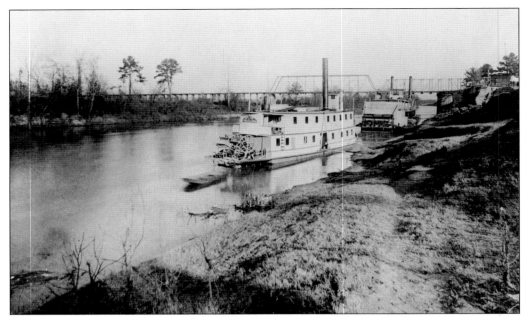

In the late 1800s and into the early 1900s, numerous museums across the country sent scientific expeditions into many of the nation's river systems to collect biological and archaeological information. One of the steamers that surveyed the Green River was the *Gopher*, an archeological survey vessel from the Franklin Institute in Philadelphia. (Library of Congress.)

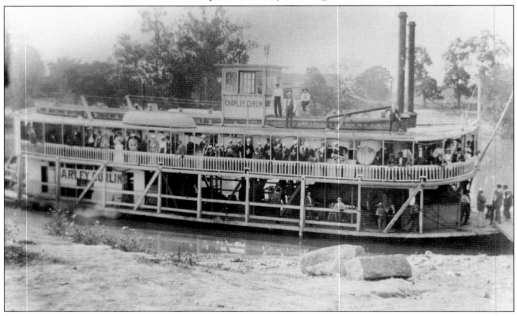

A band is shown playing on the *Charley Curlin*, which was both a packet and in private ownership. The vessel was originally built as a pleasure boat for Charley Curlin's father, Seth Curlin, a famous naturalist and taxidermist. Seth Curlin was the inventor of the inflatable canvas duck decoy and air beds. The boat was smaller than most at 80 feet long with three decks. (Cincinnati and Hamilton County Library.)

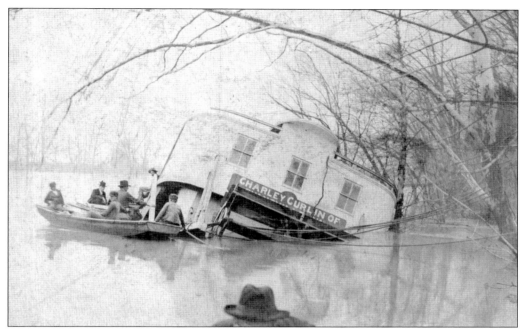

In 1905, while the steamer *Charley Curlin* was running through floodwaters, an upended log punched through the hull. The pilot managed to bank the steamer and save it. The above photograph shows the *Charley Curlin* after it hit the log. The below photograph shows how barges were moved in and set on both sides of the vessel; along with a derrick boat, they were able to refloat it. Using crossbeams, chains, and winches, it was gradually raised, allowing for the holes to be repaired—this practice was used many times when recovering vessels. The boat was eventually sold to a New Orleans line, and its fate is unknown. (Both, Western Kentucky University Special Collections.)

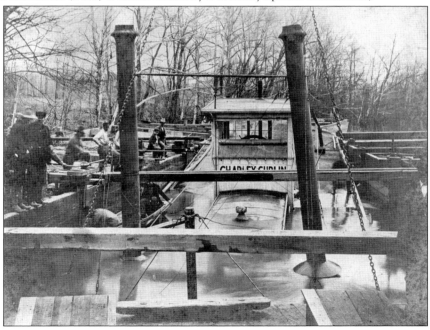

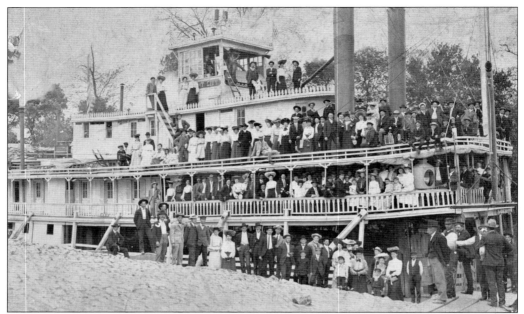

The steamer *Crescent City* was originally the *Evansville* when it was purchased by steamboat broker John Klein, who took it to Pittsburgh, where it ran in the Wheeling-Parkersburg trade. After a short period, it was brought back to the Green River and operated under the name *Crescent City* for 11 years. Much to the delight of Evansville merchants, the *Crescent City* was once again renamed the *Evansville* in 1906. (Green River Museum.)

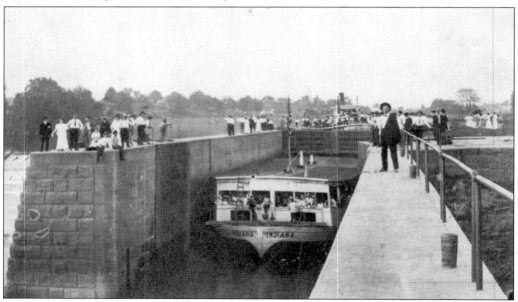

Some tourist barges were pushed by steamboats (also carrying tourists) during weekend river excursions but because the original Green River locks could only handle one boat at a time, each boat had to lock through separately. Shown is the tour barge *Indiana* being hand-pulled out of the lock until the packet *Isabella* is lowered and re-tied to the *Indiana*. (Western Kentucky University Special Collections.)

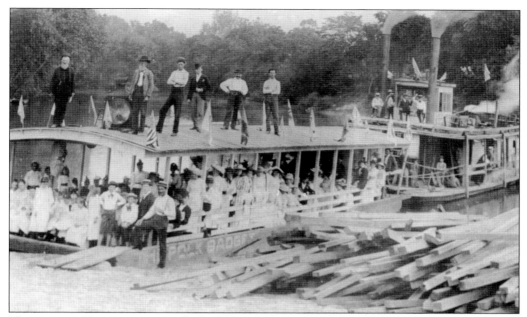

The steamer *Eleanor* is seen with the barge *The Polk Badget* loading tourists for an excursion somewhere along the Green River in the early 1900s. Tourist barges were common, as they offered a cheaper ride and usually only consisted of a day on the river. Many excursion barges typically traveled along stretches of the Green and Nolin Rivers near Mammoth Cave. (Cincinnati and Hamilton County Library.)

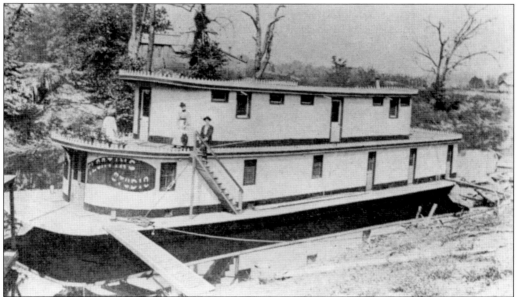

Schroeter Floating Studio operated from 1890 to 1920. Henry O'Neil Schroeter, with his wife, Emma, and sons Henry and Clifford lived on the boat, which was towed between towns and anchored for days while they made family portraits. Schroeter claimed his prints did not fade because he washed them in the mineral-rich Green River. Many family portraits remaining today were taken by the Schroeter family. (Cincinnati and Hamilton County Public Library.)

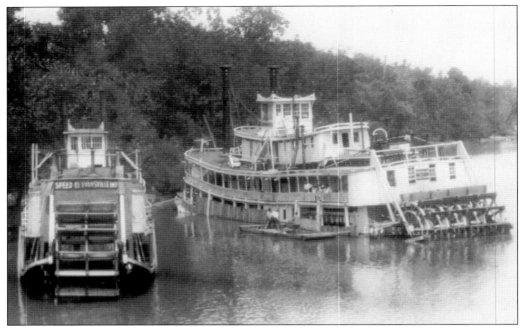

On the left, the steamer *Speed* is assisting the *Evansville* after its sinking at Aberdeen on July 11, 1919. A diver named Ed Moore was brought in from Cincinnati to repair a bulkhead on the *Evansville*. Moore said, "the boat was in a precarious position, almost breaking in half." By August, the *Evansville* was raised and towed downriver for repairs. The *Lena May* took over her route until the repairs were completed. (Cincinnati and Hamilton County Library.)

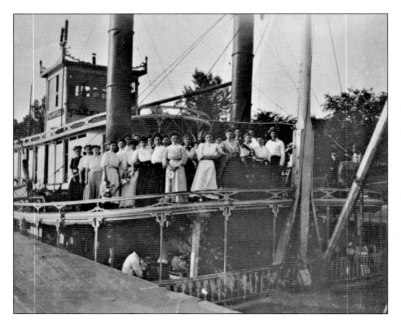

Citizens of Morgantown pose on the *Evansville*. The pilot house on top featured the "wildcat whistle." Capt. Eugene "Genie" Lunn was known for playing tunes on the whistle, which could mimic wild animals screaming. Everyone along the river knew when the *Evansville* was coming. (Green River Museum.)

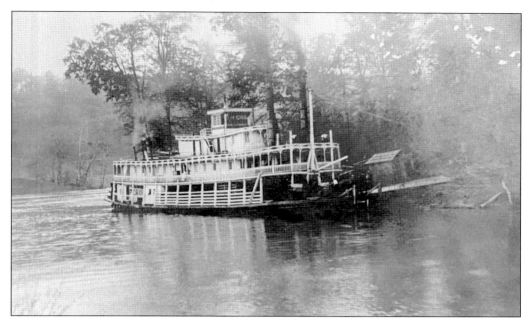

The *Chaperon* is moored at the mouth of the Nolin River on a tourist trip. According to Agnes Harralson, she was sold to Capt. Gid Mountjoy in Greenwood, Mississippi, and the name changed to *Choctaw*. The *Choctaw* operated until May 8, 1922, when she burned at Melrose Landing on the Tallahatchie River. Former Green River captain Courtney Ellis saw the remains of the *Chaperon* during low water years later. (Norman Warnell.)

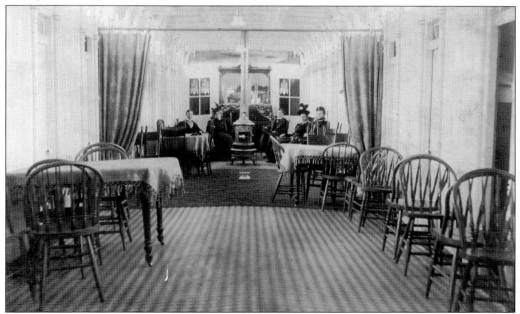

Although the dining room on the *Chaperon* was not as plush as that of the *Evansville*, travelers received high-quality meals and service. In the 1870s, on another boat, roustabouts shot a deer along the way and served venison to the guests. By the 1900s, boats had professional cooks and staff. One of them was Sam Radcliff of Morgantown. (Western Kentucky University Special Collections.)

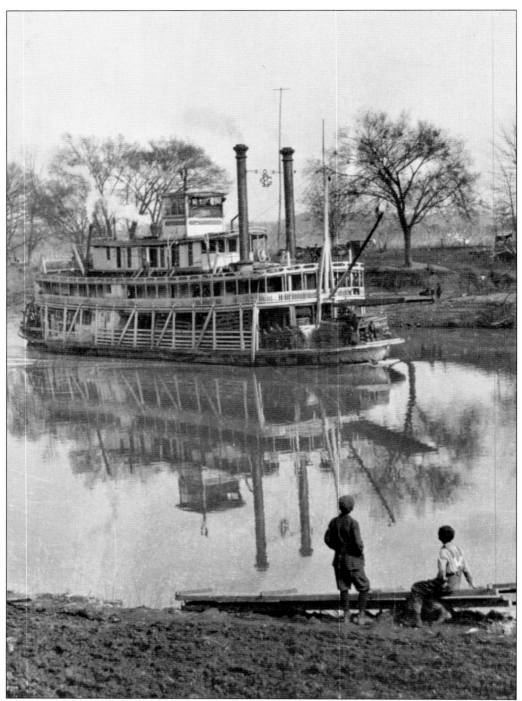

George Dabbs took this photograph of the steamer *Bowling Green* passing the Morgantown Landing. The two boys watching the boat likely wanted to work on the river. Most members of riverboat crews, from captains to deckhands, were from small towns along the river. (Western Kentucky University Special Collections.)

Capt. Charles Sturgeon directed a typical crew of six to eight roustabouts unloading freight from the packet *Bowling Green* at Rochester. Sturgeon was the last captain of the *Bowling Green*. He spent practically his entire life as a steamboat man on the Green and Ohio Rivers, beginning as a clerk when he was 18 years old. (Western Kentucky University Special Collections.)

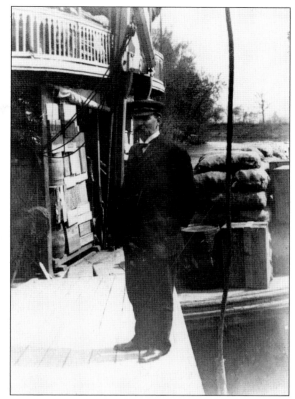

George Dabbs took this photograph of the interior of the *Bowling Green*, which shows the doors to passenger cabins. A typical crew included a captain, two pilots, first and second mates, clerks, a chief engineer, a boiler crew, and roustabouts. The crew members in this photograph are, from left to right, Ross McElroy, Harry Mayhew, L.A. McMurtry, Kim Thompson, unidentified, Capt. Charles Sturgeon, Elmer Pendley, unidentified, and Sam Smith. (Western Kentucky University Special Collections.)

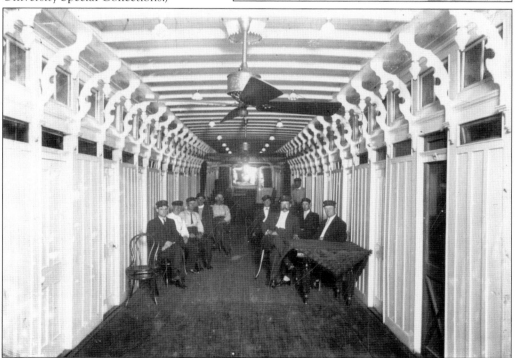

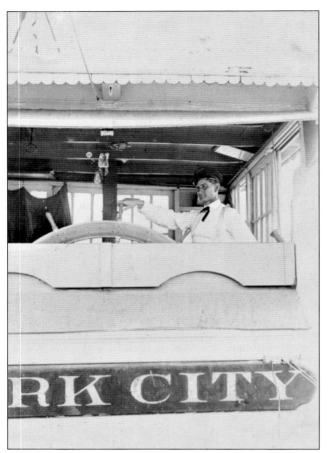

One of the best-known steamboat pilots in the trade was Buck Wayne from Calhoun, who is pictured at the helm of the *Park City*. The *Park City* was originally called the *Gayoso*. Other known crew members who worked on this packet include Joe Kittinger, Jett Hines, and Edgar Williams. (Green River Museum, George Dabbs Collection.)

The *Park City* was built in 1900 and was said to have been one of the best-handling steamers on the Green River. Although it worked the Green for many years, it was moved to the Kentucky River trade line, where it ultimately sank after hitting a snag near the community of Sunnyside on December 6, 1909. (Green River Museum, George Dabbs Collection.)

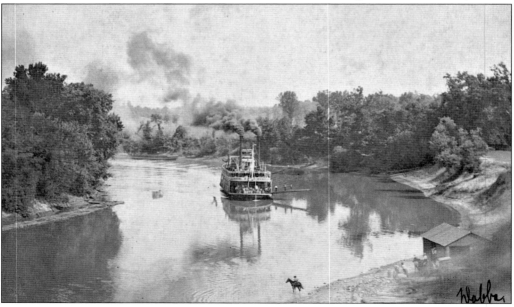

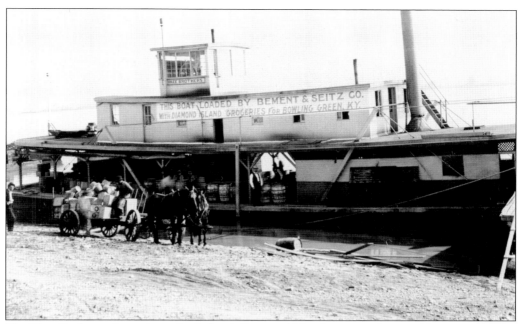

The *Three Brothers* is shown being loaded with Diamond Island groceries for a weekly trip to Bowling Green. The Diamond Island brand made items from flour to baking powder, their own brand of catsup, flaked oats, coffee, and cigars. The company sent a grocery boat up the Green River every week from the late 1800s into the early 1930s. (University of Southern Indiana.)

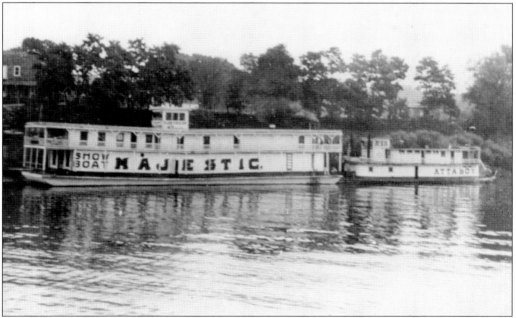

From 1900 to 1930, the showboat *Majestic*, towed by the *Attaboy*, worked the Green River and other tributaries of the Ohio. The boat was a floating theater, with quarters for about 20 performers. The *Majestic* was on the rivers from spring through fall, but remained tied up in small rivers during the winters to avoid the ice. (Western Kentucky University Special Collections.)

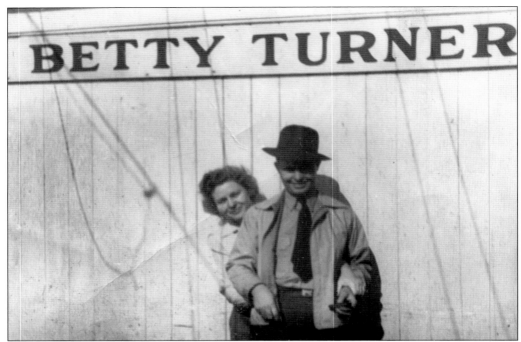

Above, towboat captain Tommy Melton is pictured with his wife, Mary, on the *Betty Turner*. In 1939, Melton, along with Capts. Jimmy and Tom Hines, was part of a group responsible for getting the locks and dams improved along the Green River up to river mile 103 at Rochester. Because Melton was responsible for towing gasoline during World War II, he was not drafted; his job was more important. Below, the *Betty Turner* is towing asphalt downstream on the Nolin River. Kyrock was only a few miles upstream from the Nolin River's confluence with the Green, and while it was only a short run, the hard bends in the river generally required that the towline of barges be broken on at least two river bends to allow barges to maneuver around them. (Both, Marilann Melton and Courtlann Atkinson.)

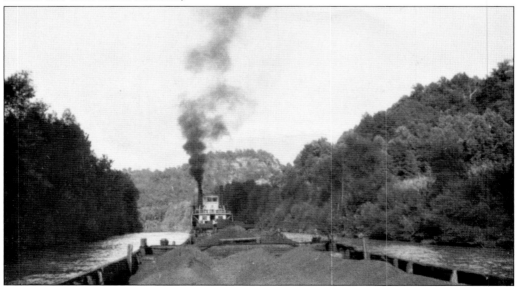

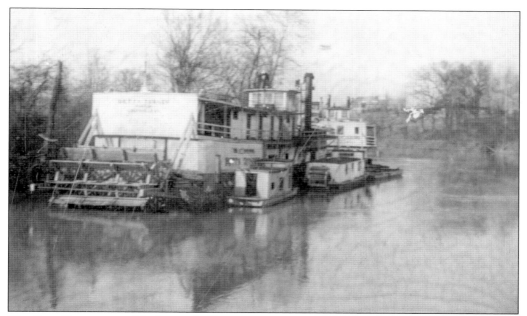

The *Betty Turner*, owned by James R. Hines Towing, was the last paddlewheel steam towboat to operate on the Green River. *Betty Turner's* whistle was salvaged from the packet *Evansville* after it burned at the Bowling Green wharf in July 1931. The *Betty Turner* was sold in 1947 and converted to a floating machine shop for the fleeting area at the mouth of the Green. (Western Kentucky University Special Collections.)

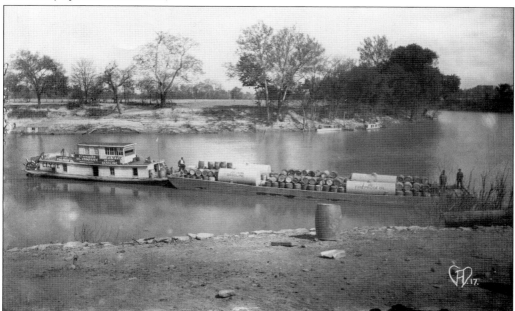

This image shows *Little Clyde* towing a gas barge at Livermore. Built at Rumsey in 1906, *Little Clyde* also towed the showboat *French's New Sensation*. In 1917, *Little Clyde's* name was changed to *Winona*. In 1921, it was towing railroad ties and pig iron on the Tennessee River. It burned some years later while pushing the showboat *Goldenrod* near St Louis. (McLean County History Museum.)

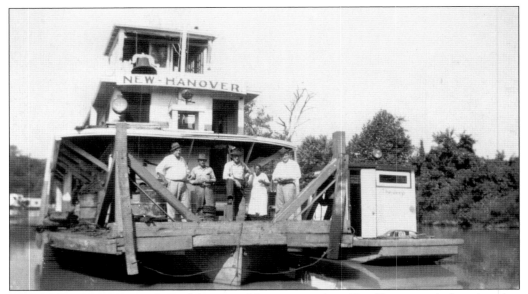

Pictured here are some members of the crew of the steam towboat *New Hanover*, including the pilot, boiler crew, and cook. The small boat on the side was named *The Jeep*, and was used for shuttling supplies between the tow and the Barren River wharf at Bowling Green. All boats were given names for better identification. (Marilann Melton and Courtlann Atkinson.)

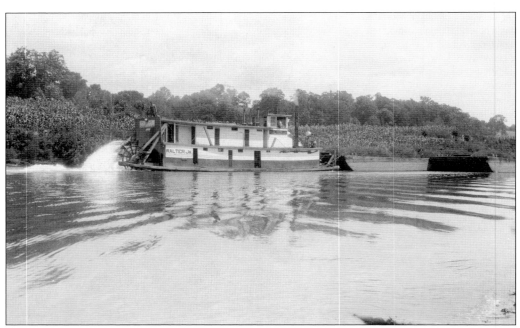

Just above Lock 6, the towboat *Walter Jr.* is upbound with lights (empty barges) from Bowling Green to pick up full barges of asphalt at Kyrock on the Nolin River. The town's name was derived from the Kentucky Rock Asphalt Company, which mined the naturally occurring asphalt. Each tow made several trips throughout the week, returning empties and towing asphalt back to Bowling Green or Evansville. (Open Parks Network.)

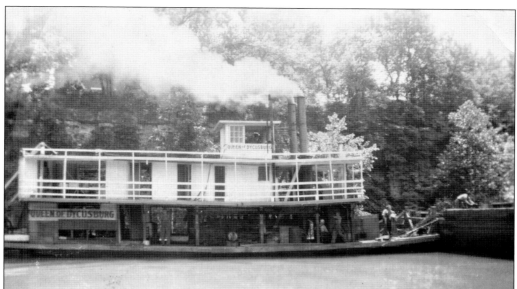

The *Queen of Dycusburg* is shown above with an eight-man crew. The steam power was provided by coal, and during a normal trip, the entire lower deck was stacked with coal to supply fuel to the boilers. Two men typically shoveled coal into the boilers the entire time the boat was underway. At right, the *Queen of Dycusburg* is heading downriver on the Green towing asphalt from Kyrock. This 60-horsepower towboat was operated by James R. Hines Towing. The boat was built in 1928 and operated on the Cumberland, Green, Ohio, and Mississippi Rivers. It was sold in 1947 to the Idle Hour Boat Club in Bellevue, Kentucky, and converted to a clubhouse. (Above, Marilann Melton and Courtlann Atkinson; right, Open Parks Network.)

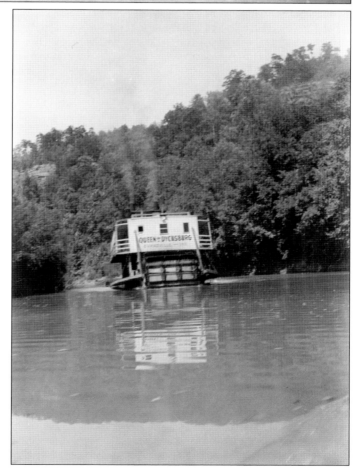

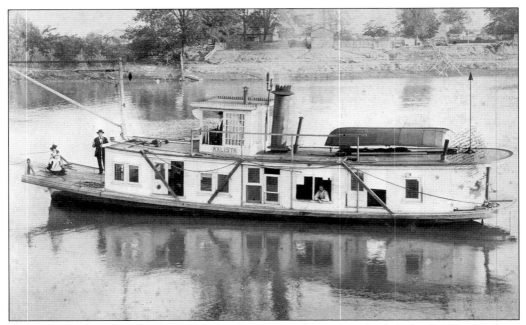

This is the *Kallista*, purchased in 1899 by Capt. Porter Hines. He also bought the *Ferncliff*. Both small boats were contracted to carry the mail between Livermore and Calhoun for $600 per year. The *Kallista* made two trips each day carrying passengers and mail until 1902, when Hines sold half his interest in the boats to Walter G. Hougland. (Western Kentucky University Special Collections.)

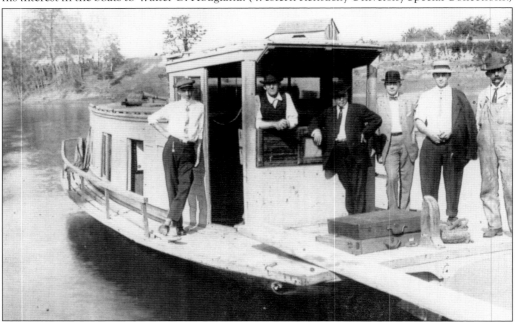

The *Paradise* mail boat operated between various towns, usually no more than two or three where mail could be delivered once or twice a day. While the primary cargo was mail, because these boats were so prompt, they would also often carry passengers, sometimes picking them up along the riverbanks between towns. (Barry Duvall.)

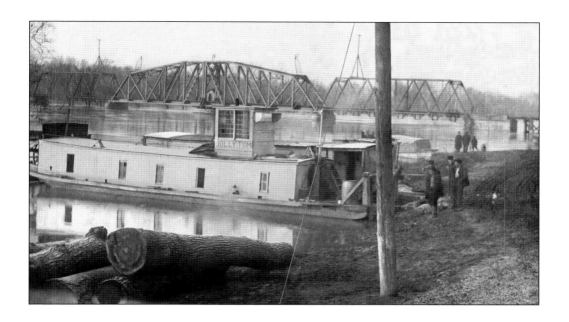

The *Jolly Tom* (above) was one of many mail boats. Mail service was poor over most of the region due to unreliable road conditions. However, mail boats such as the *Jolly Tom* were not only reliable and prompt, it was said that one could set their watch by them. The mail boat *Josephine* below ran mail and passengers between Livermore and Calhoun, sometimes twice a day. Many local businesses advertised that specific items would be available after the mail boat arrived. (Both, Holly Johnson.)

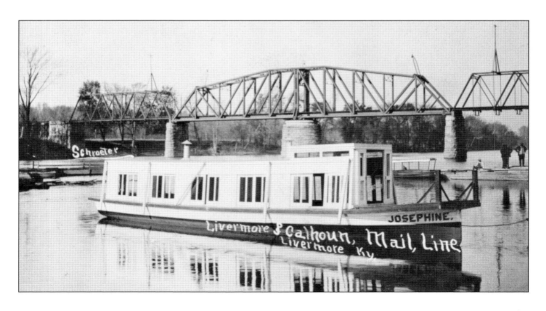

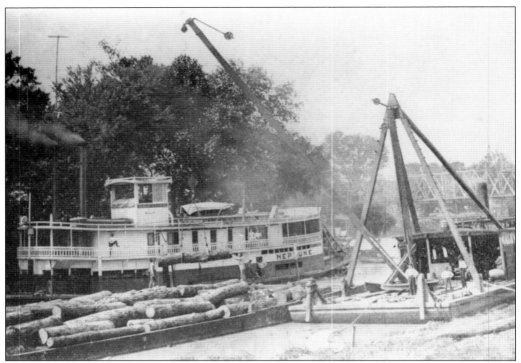

A separate barge with a crane is loading logs on barges set to be towed by the steamer *Neptune*. As more towboats came up the Green River, there was less need to build and float log rafts. Barges quickly replaced the rafts, as they were faster, safer, and more cost-efficient. (Cincinnati and Hamilton County Library.)

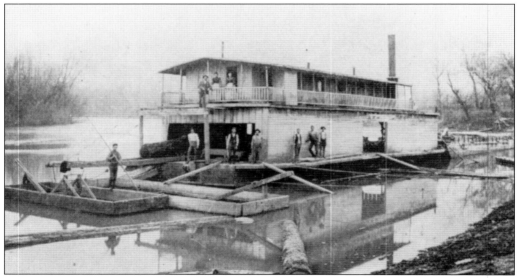

Log rafts were eventually replaced with sawmill boats such as this one. Local farmers could have the mill towed to a particular area, where it was set up to saw lumber to specifications, or lumber would be offloaded onto a barge and sent to either Evansville or Livermore. As more roads were built, portable sawmills were moved by trucks instead of boats. (Cincinnati and Hamilton County Library.)

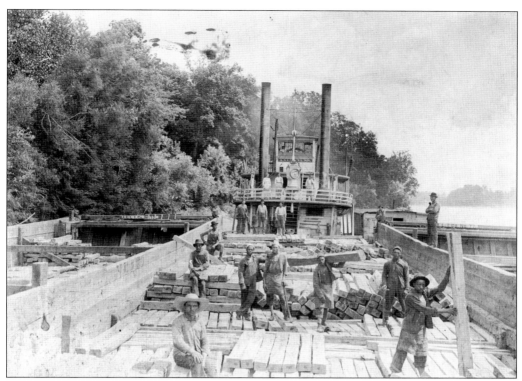

A tie barge and crew are locking through Lock 4 at Woodbury. Railroad ties were originally hewn out of logs with a broadax and adze. Paid for each tie cut, good cutters could typically square up a tie in around 15 minutes. Those who carried the ties were paid an average of 1.5¢ for each tie carried onto the barge. (Green River Museum.)

The *Evansville is* locking through at Rumsey. Travelers had varying experiences on steamboats, but many were good. Agnes Harralson quoted Will T. Carpenter's 1902 *Waterways Journal* article: "There was a pleasure about a steamboat trip that can never be gotten out of a journey by rail . . . there is no monotony on a steamboat . . . always diversion." (Photograph by George Dabbs, Courtesy of Green River Museum.)

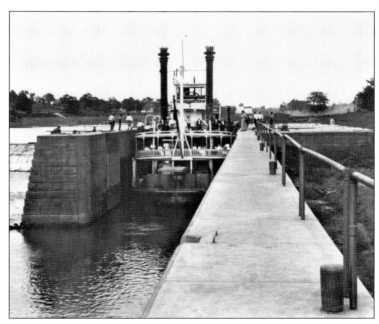

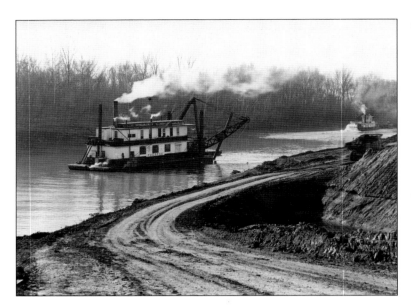

The dredge *Pacific* is seen working on the lower approach to Lock and Dam 2. The Green River received an appropriation of $16 million to improve Locks 1 and 2. Prior to this, the locks could only accommodate one barge at a time. The dredge is opening the nine-foot channel needed to safely move loaded barges. (McLean County History Museum.)

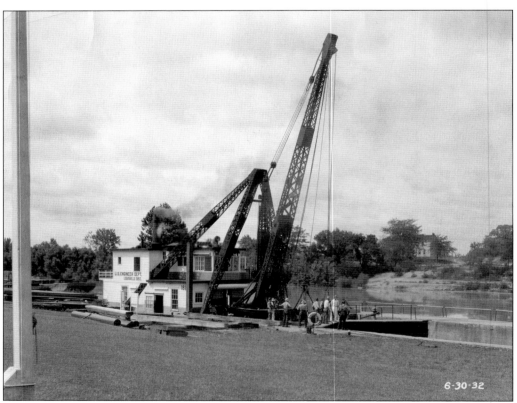

A US Army Corps of Engineers steam-powered crane is shown replacing gates at Rochester Lock and Dam 3 in June 1932. The steam-powered boat and crane were also used to remove trees out of the river or, in this case, lift heavy equipment during construction. Across the river in the background is Skilesville in Muhlenberg County. (Green River Museum.)

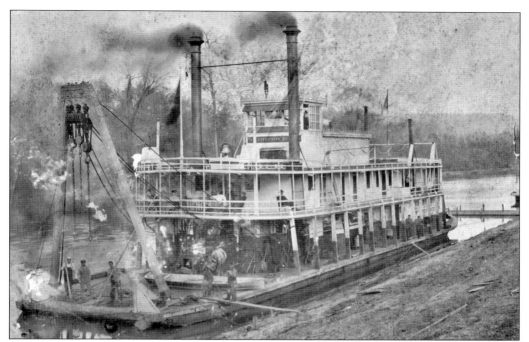

The dredge boat *William Preston Dixon* is shown locking through Lock and Dam 3 at Rochester. This boat was built in Jeffersonville, Indiana, in 1890 by Howards Boat Company. It was 124 feet long with a 32-foot beam and operated on the Green and Barren Rivers. (Green River Museum.)

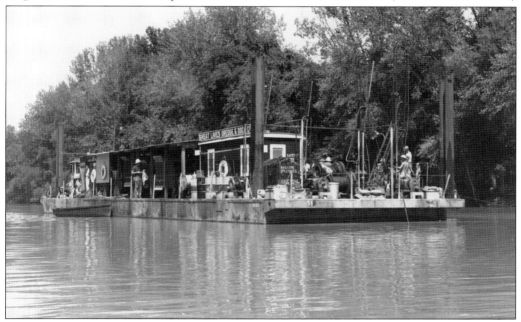

Maintenance of the river channel was a continuous operation. For many years, the US Army Corps of Engineers did the work, but it was occasionally completed by outside contractors. Here, a Great Lakes Dredge and Dock Company drill boat is working on channel excavation and dredging on the Green River in 1955. (McLean County History Museum.)

How would you like to be with me in SO. CARROLLTON, KY.

Every community along the Green River hoped tourists would stop by and visit. This was a typical postcard that could have been purchased and mailed to friends. South Carrollton was a favorite spot for Sunday afternoon river outings. (Barry Duvall.)

Two

A Trip Down the River
in 1913

From the 1800s to 1931, packets carried hundreds of passengers each year along the Green River and through the communities that make up Green River country. As railroads became more prominent in the early 1900s, trains began replacing steamboats. While train trips were faster and easier, many people still preferred steamboat trips along the river. Steamboat companies immediately took advantage of this and offered weekly trips from Evansville to Mammoth Cave. Once tourists visited the cave, they would take a small train pulled by the locomotive *Hercules* from Mammoth Cave to Glasgow Junction (now Park City) to board a larger passenger train on the Louisville & Nashville Railroad. *Hercules* was originally part of an interurban train in Memphis that was purchased to make the nine-mile trip each day.

Most tourists take photographs, and although their names are not known, the women who took the photographs in this chapter captured interesting aspects of the trip and experiences that provide a feel for what it was like for them going into what was perceived at the time as wild country. Because all of the photographs are black and white, the authors did not include landscape images. Many were taken in the afternoon, and those who have lived or spent time along the Green River can imagine what they saw as the sun painted the shoreline each afternoon and morning.

It is regrettable that the names of these photographers are lost to history. However, this brief glimpse of their trip is preserved in 24 scenes they photographed to show everyday life during their trip to Mammoth Cave on August 17–23, 1913.

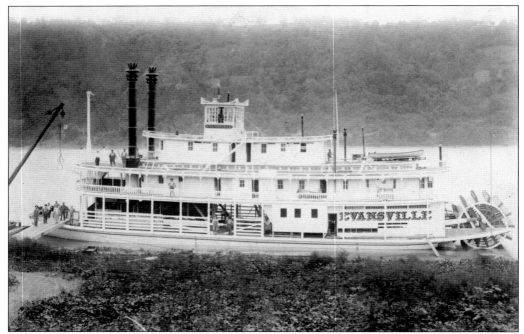

The *Evansville* was a packet boat with 22 staterooms for passengers. It could carry up to 200 head of cattle on the lower deck. The second deck, which housed passengers, was called the boiler deck, although the boilers were on the lower deck under the stacks. The top deck was called the Texas (or hurricane) deck. While cattle may have been transported on the lower deck, the below photograph shows how stylish the dining room was. Servers and cooks provided top-of-the-line food and service. Virginia Flener Hurst of Morgantown told a story of having half a fresh, cold cantaloupe filled with homemade ice cream served to her and her friends on their trip. (Above, University of Kentucky; below, Western Kentucky Special Collections.)

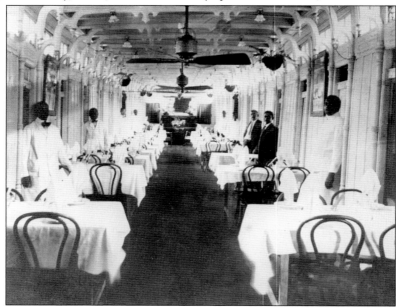

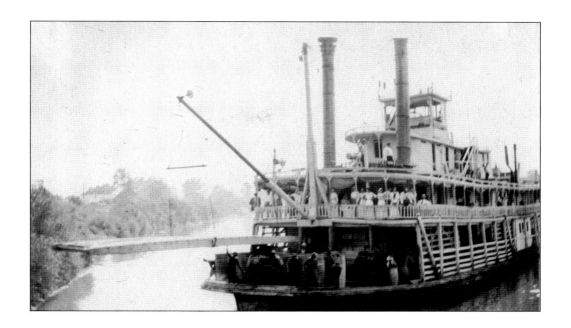

The above photograph shows the front of the *Evansville* with two large smokestacks for the boilers, which provided power for the paddlewheel. The lower deck also carried livestock, but more importantly, at each stop, it was loaded with firewood provided by locals. The below image shows the back of the *Evansville* with smaller stacks for woodstoves scattered throughout the boat for heat during the winter. The boilers used a tremendous amount of firewood—more than could be carried for the entire trip without sacrificing space for cargo. (Both, Mammoth Cave National Park.)

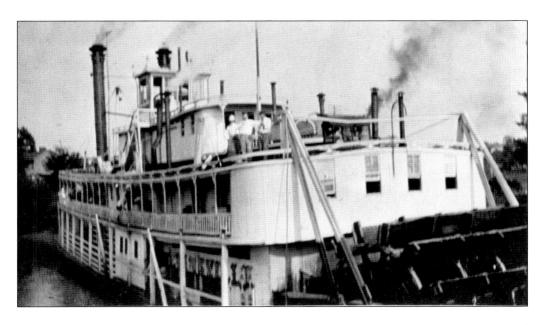

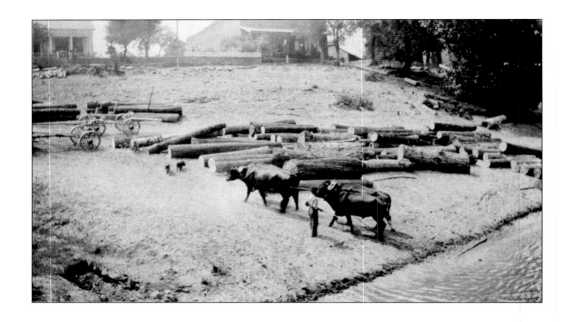

These photographs provide a glimpse into logging in 1913, showing logs decked at the landing in Paradise that would later be assembled into a raft. After logs were cut in the forest, two or three at a time were hauled to the river on wagons pulled by oxen. The photograph below shows oxen that had been walked into the river so they could cool off before they started their trip back to the woods. These log rafts would have been held here until high water, when they could be floated to Livermore or Evansville. (Both, Mammoth Cave National Park.)

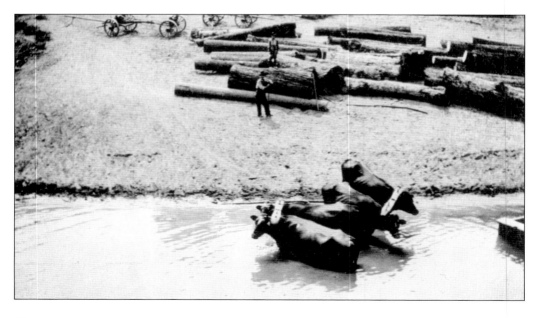

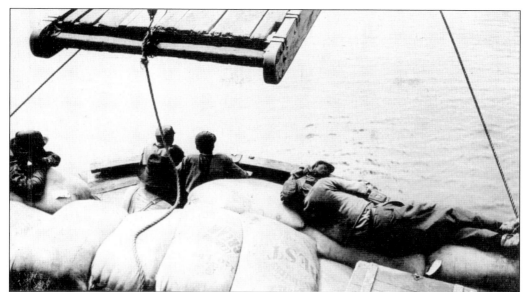

Above, roustabouts are sleeping on feed sacks stacked on the bow of the boat. The work was grueling, with the men loading and unloading freight, supplies, and wood for the boilers at each stop. They did not have sleeping quarters, so during warm weather, they slept on the bow. During cold or inclement weather, they slept in the boiler room. Some only worked for a few stops in exchange for passage. The photograph at right shows roustabouts unloading cargo at Calhoun Wharf. Although the trip was a river tour, freight was still delivered and picked up at each port. To keep schedules, loading and unloading had to be completed as quickly as possible. (Both, Mammoth Cave National Park.)

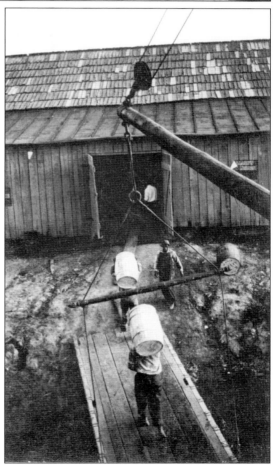

At Cromwell Ferry, horses were transported across the river. This ferry started in the early 1800s and is believed to have originally been called Borah's Ferry, which connected Ohio County with Logansport and Morgantown. The below picture shows freight waiting to be loaded. The roustabouts are loading large barrels called hogsheads. Starting in colonial times, hogsheads were used to transport tobacco and other products. Fully packed, one hogshead could weigh up to 1,000 pounds. This was a common way to ship goods via riverboat. (Both, Mammoth Cave National Park.)

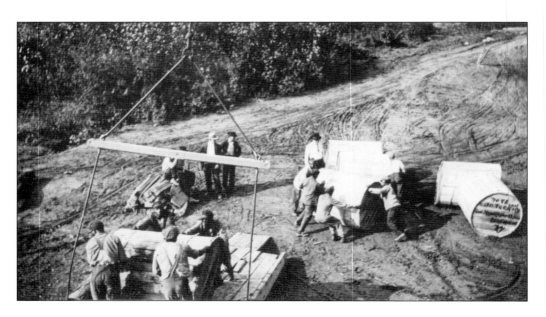

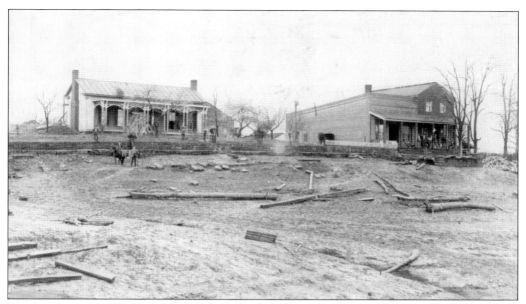

Paradise, formerly called Stom's Landing, depended on river traffic. Local farmers loaded livestock, logs, and other goods onto riverboats here. In the background is the Paradise post office. Established in 1852, it was closed in 1967 when the Tennessee Valley Authority purchased and tore down the entire town due to health concerns caused by air pollution from the nearby coal utility plant. (Barry Duvall.)

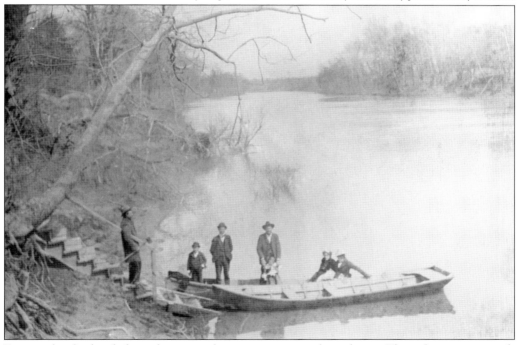

For people who lived along the river, a boat was as essential as a horse. Those fortunate enough to be near a road or crossing could obtain additional income by ferrying people across the river. This photograph features one of the boats at Paradise, where residents or travelers could cross the river between Muhlenberg and Ohio Counties. (Barry Duvall.)

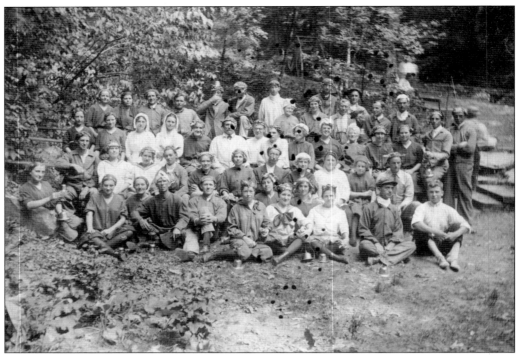

The caption on the above photograph reads, "Ready for first trip into Mammoth Cave including Echo River and the Corkscrew." Mammoth Cave was known across the nation and was as popular as Niagara Falls. From the 1800s and into the early 1900s, casual dress was not an accepted norm. Even those who worked through the week would dress up on their days off so it was not obvious they were in the working class. However, the fashionable dress worn above ground was unsafe to wear underground in the cave, so "costumes" were designed for women to wear. These consisted of shortened dresses with either bloomers or trousers worn beneath the dress. Most trips in the cave lasted from six to eight hours. The photograph at left shows two of the women after their grueling eight-hour cave trip. (Both, Mammoth Cave National Park.)

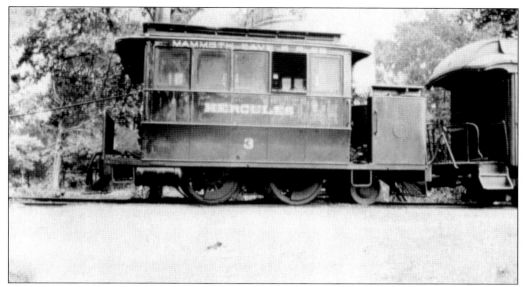

The steam engine *Hercules* pulled passengers the 8.7 miles from Mammoth Cave to Glasgow Junction (Park City), where they would board a larger train to take them back to the *Evansville* or *Bowling Green* for the trip back down the Green River. On occasion, the *Hercules* could not pull hills, and passengers would have to get out and walk behind the train. (Mammoth Cave National Park.)

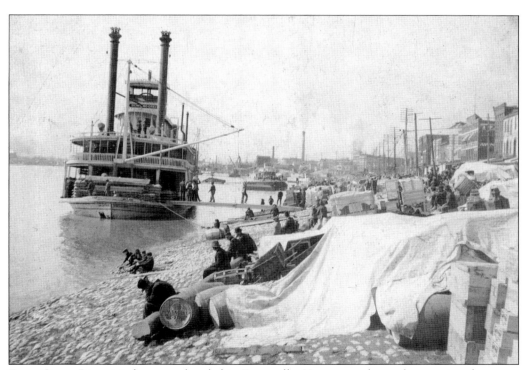

Every Green River trip began and ended in Evansville. Here, roustabouts from various boats are waiting with cargo to be loaded onto the lower decks of packets. Although this was an excursion trip, freight was still delivered and loaded at each port. (Mammoth Cave National Park.)

Brothers John, George, and Lute Davis are pictured above in 1918 building a log raft at Livermore. The large brace and bit was used to drill holes through four- to five-inch split saplings called "strapping," which was laid over the top of the raft to hold it together. Strapping was fastened by driving hickory pins through the straps and into the logs, which were also pinned on the ends with metal wedges and chains. Because pins continually popped out, a sack of them was kept on the raft to replace them during the trip. Below, a Livermore Timber Company crew poses on a completed raft. Because oak, beech, and walnut would sink, these "sinker" logs were alternated with lighter woods such as tulip popular that were called "floaters." (Both, Holly Johnson.)

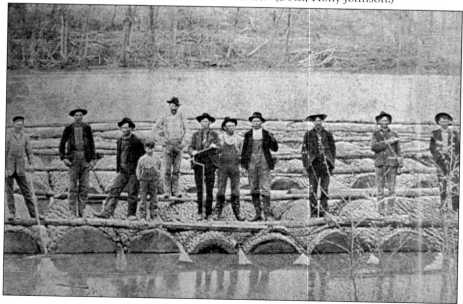

Three

MAKING A LIVING
ON THE GREEN

Some of the most fertile land in Kentucky is found along the Green River, and farming has long been a major source of income for residents along the river. Large expanses of hardwood forests were also important, and loggers moved thousands of logs down the river each year. Evansville expanded and made its fortune off logs rafted down the Green River. In 1905, there were 17 furniture manufacturing companies in Evansville. During the 1880s, Reitz's sawmill in Evansville produced more board feet of hardwood lumber than any mill in the United States. Livermore also developed into a hardwood manufacturing center.

But one industry typifies the Green River Valley more than any other—coal mining. In 1820, the first coal mined and barged down the river came from the Mud River Mine in Muhlenberg County.

Many people made a living directly from the river. Commercial fishermen provided fresh catfish, bass, and walleye to residents and markets. Winter meant prime fur, and every small community along the river had trappers who harvested mink, muskrat, and raccoon pelts along the banks. Fur-buyers traveled the valley to purchase pelts that were shipped to New York furriers for manufacturing coats. From the 1800s until the 1940s, shells of freshwater mussels were the primary source of buttons on clothing. Temporary mussel camps developed along the river each summer as entire families worked to process shells that were purchased by the ton.

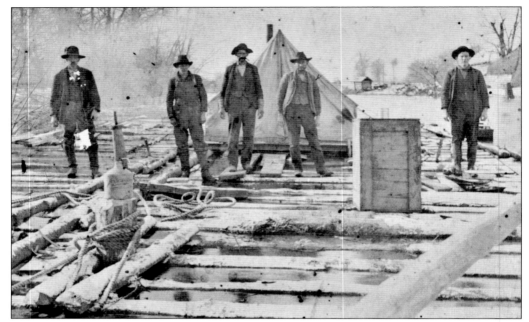

Most log rafts were floated to Evansville. Log rafting was one of the most dangerous occupations on the river. The log sticking up in the center of this raft is the checkpoint, which allowed the crew to tie up each night. The long poles in the foreground are oars, which were operated by a skilled pilot who averaged $1.50 per day in wages. (Green River Museum.)

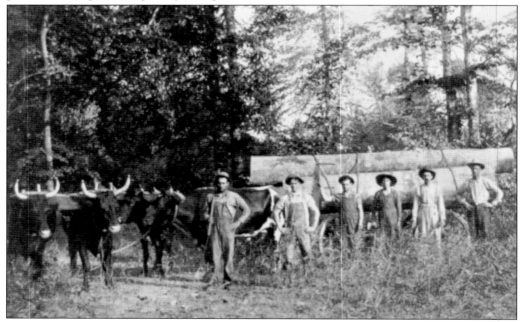

This logging crew is pictured in 1910 in McLean County. Oxen worked in pairs, and large logs required from one to three pairs to pull them. Logs were cut in 12-, 14-, and 16-foot lengths according to species and destination market. They were hauled to nearby creeks, dropped on the bank, and then floated to where they could be assembled into larger rafts in the river. (Holly Johnson.)

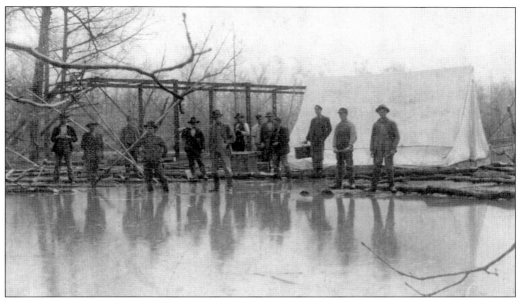

Moving logs was dependent on a rise (flood), which assured the crew had enough water to start the monthlong trip to Evansville. All supplies were on board, and the entire crew slept each night in makeshift shelters that kept out the rain and snow. Rafting appears to have peaked in 1890, when a total of 4,321 rafts passed Lock 1 at Spottsville. The below photograph shows logs delivered to Livermore Landing in the early 1900s. These logs were held here to be pulled ashore and used at the numerous hardwood mills and factories in town that built chairs, shingles, staves, or pallets. The small log in the foreground was a strapping log used to hold the raft together, showing that a portion of this raft was still assembled. (Both, Holly Johnson.)

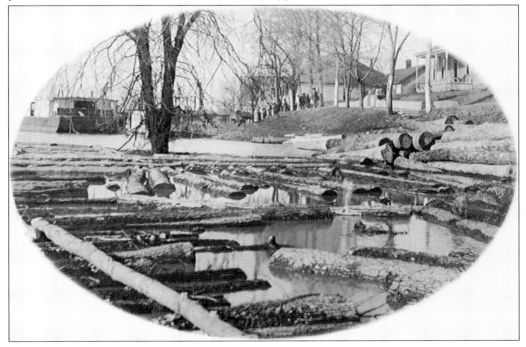

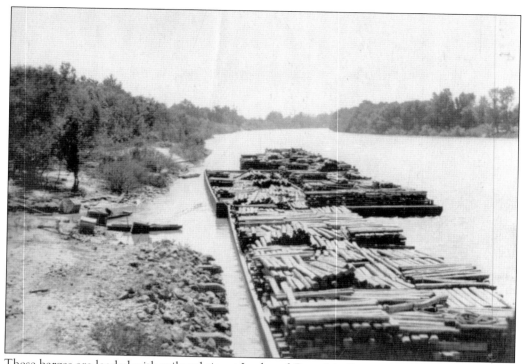

These barges are loaded with railroad ties at Lock and Dam 2 in Rumsey. Each barge could hold around 1,000 ties. Companies were paid 8¢ or 9¢ per tie for towing them to other locations. All ties on these barges were hand-hewn using a broadax and adze. One account tells of more than 1.5 million railroad ties being towed down the Green River during one year. (Western Kentucky University Special Collections.)

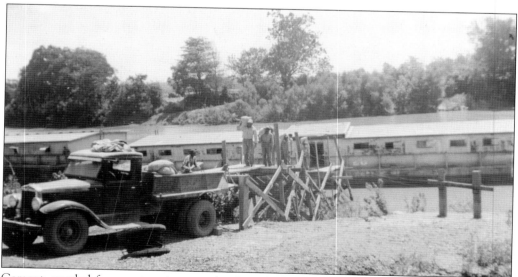

Cement, needed for construction, was hard to obtain in the valley. Here, men are unloading bagged cement at the wharf in Morgantown. Cement could only be shipped up the river by barge to warehouses in each of the towns. (Western Kentucky University Special Collections.)

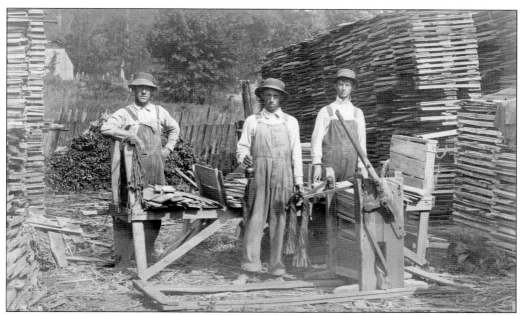

The above photograph from Quigg Pallet Mill shows men who appear to be working on white oak staves. The mill was along the river in Livermore. Early newspaper articles listed the mill as producing wooden chairs, white oak staves (sides of bourbon barrels), and headers (tops and bottoms of barrels), as well as pallets. Below is a shingle factory in 1900. Before the advent of asphalt shingles, houses and buildings were roofed with wood shingles that were hand-split from 24- to 30-inch-diameter logs that were two feet long. Using a wood mallet and a tool called a froe, shingles were split from the log. These were primarily made from various oaks. (Both, Holly Johnson.)

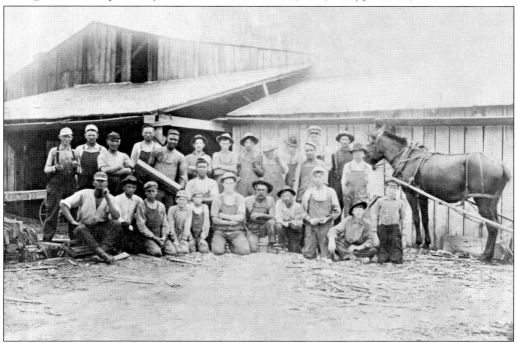

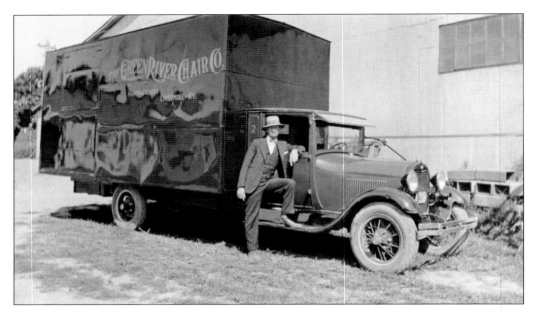

Organized in 1905, the Green River Chair Company was highly successful by 1928. Above, Hugh Thornberry stands next to a new company truck used to deliver the straight-back cane-bottom chairs that were manufactured from lumber harvested upstream from Livermore. Below, workers at the Green River Chair Company are pictured in 1906. One of the main types of wood used was beech. The cane bottoms were made from rattan, a species of climbing palm that was harvested in China and floated down rivers—much the same way logs were floated downriver in Kentucky—and then purchased by German merchants who sold the prepared cane to factories in Livermore. (Both, Holly Johnson.)

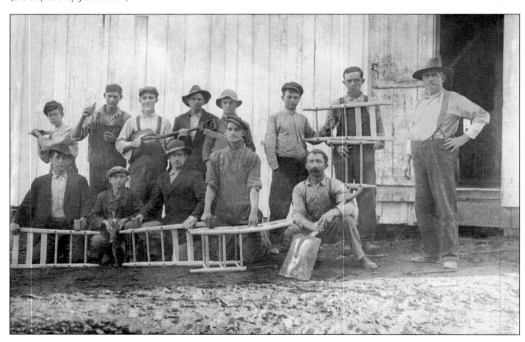

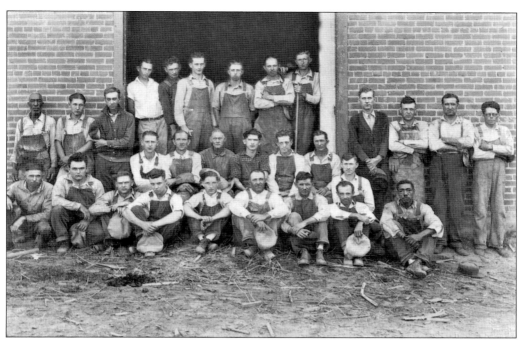

Livermore Chair Company was owned by W.E. Renders. It employed around 100 people and manufactured chairs for 51 years until it closed on April 12, 1963. The below photograph shows a wagon hauling chairs. Everyone in the family worked on chairs, and women and men who were homebound would weave the cane into the bottoms of each straight-back chair. Between the two chair factories (this one and the Green River Chair Company), more than 800,000 straight-back chairs were manufactured in Livermore each year when they were in operation. (Both, Holly Johnson.)

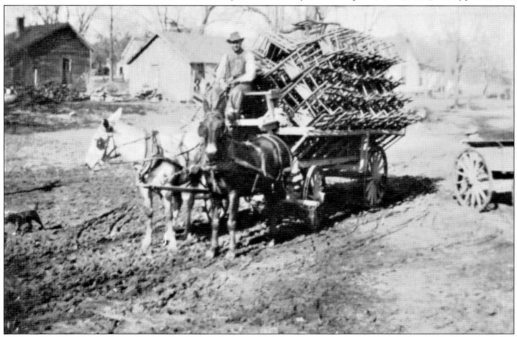

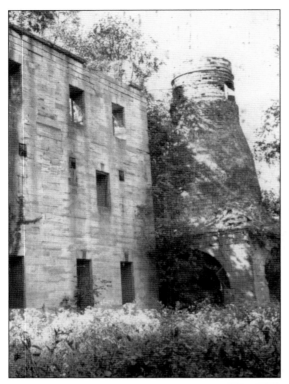

At left is the stone house and furnace stack built by R.S.C.A. Alexander at the Airdrie Iron Furnace a mile downriver from Paradise. Alexander brought iron workers from Airdrie, Scotland, who named the community after their home. The company's land included 17,000 acres and a town with numerous houses, a hotel, and stores. Below is the Airdrie furnace stack, where efforts were made to produce pig iron along the Green River in 1855. Workers used methods they were accustomed to in Scotland, but after several unsuccessful attempts, they failed to produce any usable iron, blaming their failure on the quality of the local ore; however, many engineers at the time believed that if they had modified their methods, Airdrie would have been successful. (Both, Western Kentucky University Special Collections.)

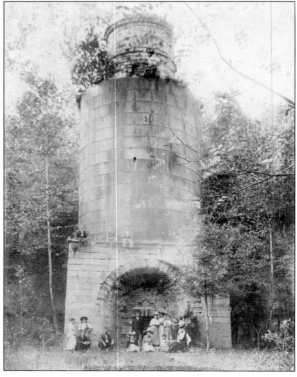

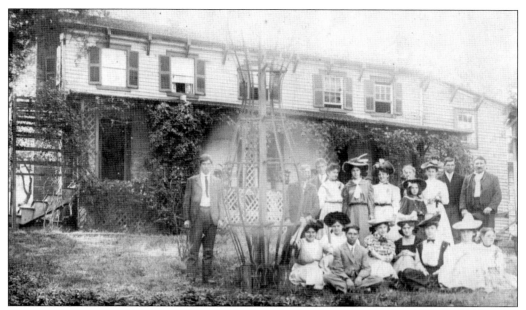

The mansion on top of Airdrie Hill was built when the furnace was started in 1855. In 1866, it was purchased by Gen. Don Carlos Buell, president of the Green River Iron Company, who made it his home. Buell maintained the grounds around the home like a park and was visited by prominent people from across the country. The house burned down in 1907. (Barry Duvall.)

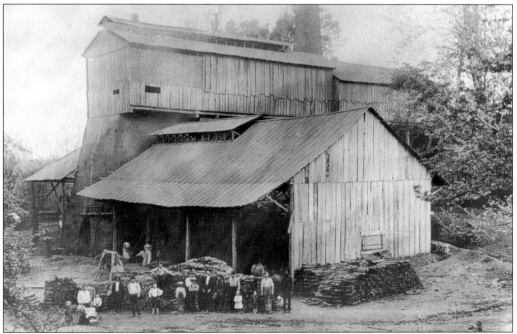

This is the storage shed at the Airdrie Iron Furnace. Before blast furnaces were developed, iron was melted with charcoal manufactured locally and kept dry and stored in sheds. Most furnaces of the time (such as the Hillman Iron Works in Lyon County) ran for 24 hours a day. They consumed around one acre of forest per day to fuel operations. (Western Kentucky University Special Collections.)

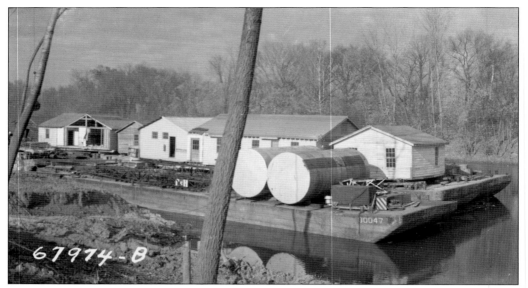

The song "Paradise" by John Prine tells of the town of Paradise disappearing due to Peabody Coal, but it was the Tennessee Valley Authority that moved residents out of Paradise in 1967 because coal ash and emissions were continually falling on the town. Seen here is a barge loaded with houses and buildings being moved from Paradise to another location. (National Archives.)

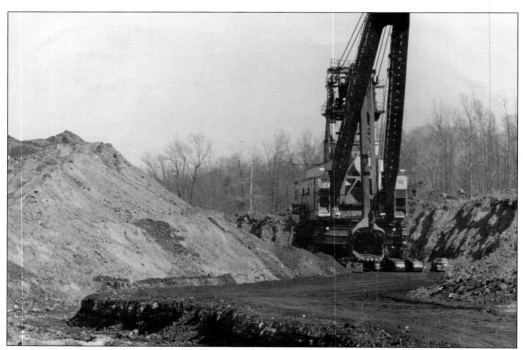

The world's largest shovel, "Big Hog" was a Bucyrus-Erie 3850-B power shovel that operated on the west side of the Green River on Peabody's Sinclair Mine near Paradise in Muhlenberg County. Big Hog was in operation for 23 years and uncovered 41 million tons of coal that was hauled to the nearby Paradise Fossil Fuel Plant. (Photograph by Ambrose Reid.)

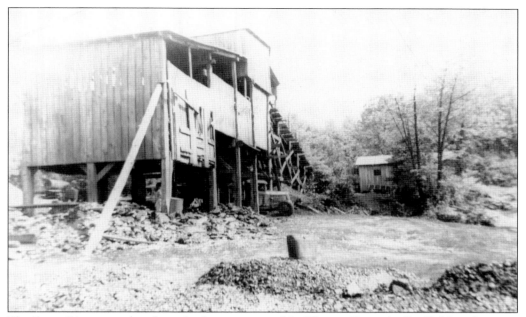

The Green River meanders through a large portion of the Western Kentucky Coalfield, and prior to more effective environmental regulations enacted in the early 1970s, many coal mines were simply abandoned when they closed, eventually becoming a source of pollution in the river's watershed. This is the Warman Coal Company's underground mine near Paradise. (Barry Duvall.)

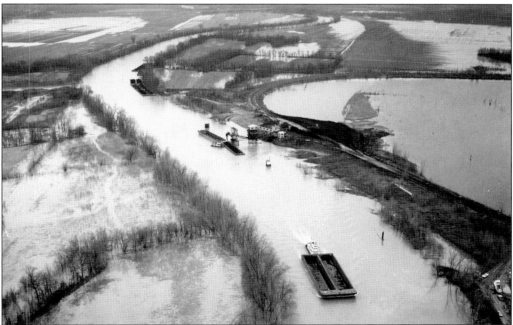

Peabody Coal Company's Ken Mine loadout facility is pictured in 1972. While the nearby Sinclair Mine was supplying coal exclusively to the Tennessee Valley Authority's Paradise plant, the Ken Mine shipped coal to the fleeting area at the mouth of the Green River. One tow is upbound with two lights, while a smaller tender is shifting barges under the conveyor belt loader. (National Archives.)

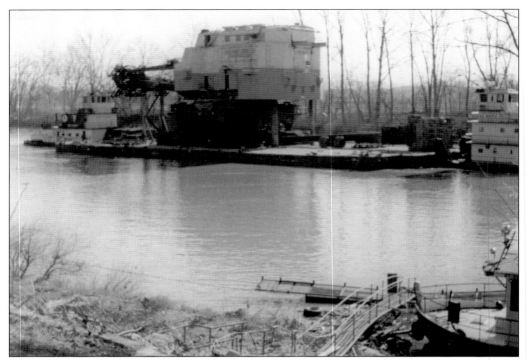

After spending the night on the shore at Birk City, towboats *Teresa Marie* and *Paul Legay* of the Evansville Barge & Marine Service company continue moving a 57-foot-high, 2,000-ton Bucyrus-Erie shovel by barge on the Green River from Rockport in Ohio County to the Green Coal Company mines near Spottsville in Henderson County. Green Coal Company purchased the shovel from Peabody Coal Company in January 1989. (Grady Ebelhar.)

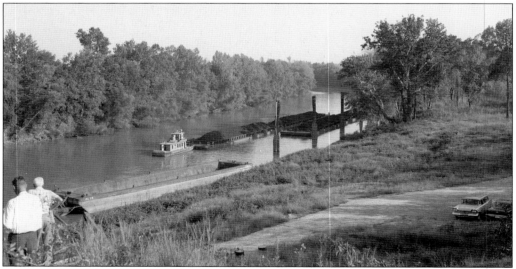

A towboat pushes barges owned by the Pittsburg and Midway Coal Company near the mine loading terminal. The crew on this towboat made daily trips delivering coal from Paradise to the Kentucky Utilities Plant near South Carrollton. River work was not without its hazards, as longtime crew member Gene Sainato was killed in 1967 when he slipped and fell off a barge. (National Archives.)

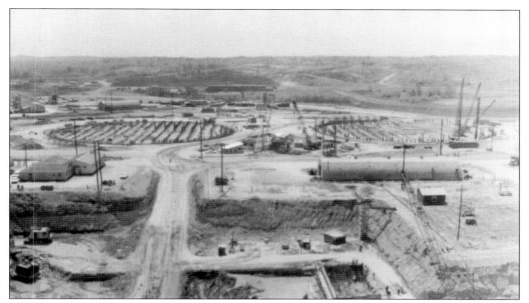

The Tennessee Valley Authority's Paradise Fossil Fuel Plant is shown under construction around 1962. The TVA, originally authorized to operate within the Tennessee River system, expanded into the Green River Valley to take advantage of the large coal reserves in Muhlenberg County. The Peabody Coal Company supplied coal to the world's largest coal-fired steam generator, which burned 20,000 tons of coal per day. (Photograph by Ambrose Reid.)

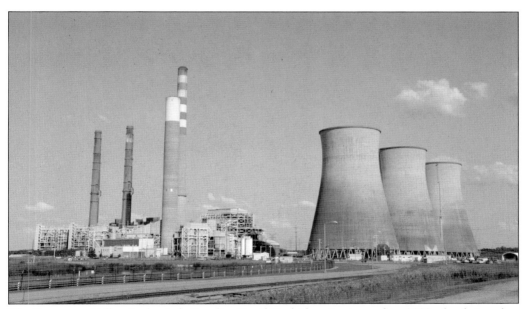

The Tennessee Valley Authority's Paradise Fossil Fuel Plant is pictured in 2022 after being shut down. This was once the most prominent facility on the Green River. Constructed in 1962, the plant originally had two generators, with more added over the years. This photograph was taken only days before the 425-foot-high cooling towers on the right were imploded, with the remainder of the plant scheduled for demolition later. (Photograph by Richard Hines.)

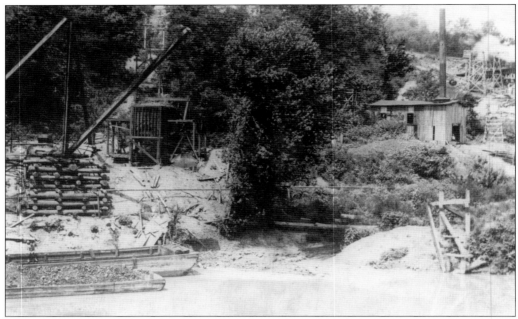

Above is the Kentucky Rock and Asphalt Company's barge loading site on the Nolin River. Bituminous sandstone, called rock asphalt, was mined along the Nolin and was one of the primary products towed down the Green River. The company was the world's largest producer of natural rock asphalt from 1920 until 1957. Kyrock asphalt was so prominent that asphalt roads were sometimes called Kyrock roads. One of the most notable roads that used Kyrock asphalt was US Highway 20 between Buffalo, New York, and Cleveland Ohio. The city of Miami, Florida, also used it, as did the Indianapolis Motor Speedway. Below is a process plant that was closed, eventually making commercial river traffic obsolete at Green River Lock and Dams 5 and 6. (Both, Western Kentucky University Special Collections.)

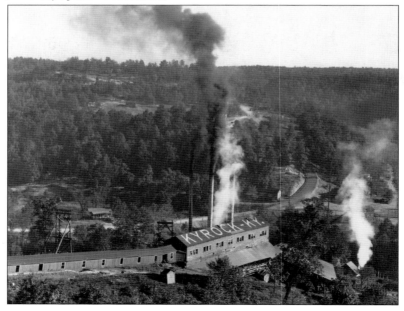

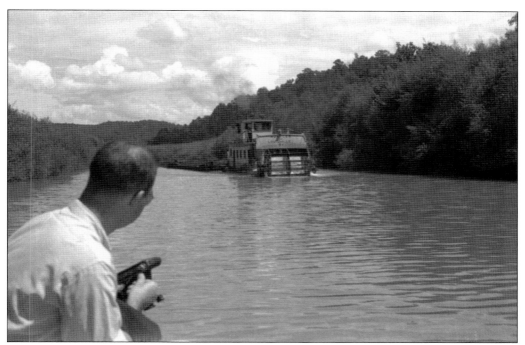

The towboat *Hustler* is towing asphalt somewhere along the upper Green River between Locks 5 and 6. This load of asphalt was from Kyrock. (Open Parks Network.)

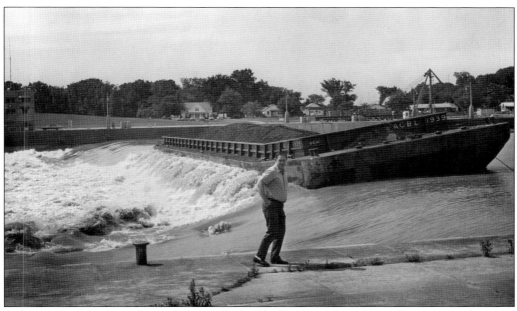

Coleman Stroud poses in front of a barge that had broken loose from the towboat *Sipsey* as it entered Lock 2 and washed over the dam. Efforts were made to free the 300-ton barge, which was loaded with 1,500 tons of coal, but after a 5,600-horsepower towboat and two bulldozers were unsuccessful in retrieving the barge, it broke loose and went over the dam. (McLean County History Museum.)

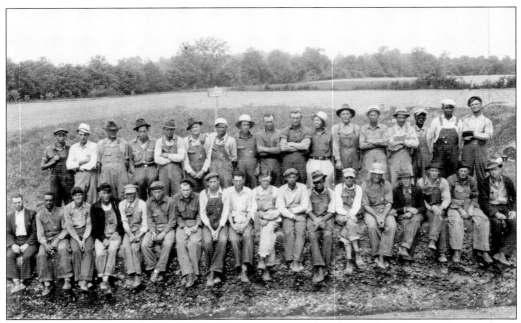

The Chiggerville site in Ohio County was one of many sites that the Works Progress Administration (WPA) funded to excavate Indian mounds and village sites along the Green River. Numerous universities also participated and supervised crews like this one in most counties along the river valley. Much about what is now known about Green River's early inhabitants was discovered by WPA archaeological excavations. (University of Kentucky Library.)

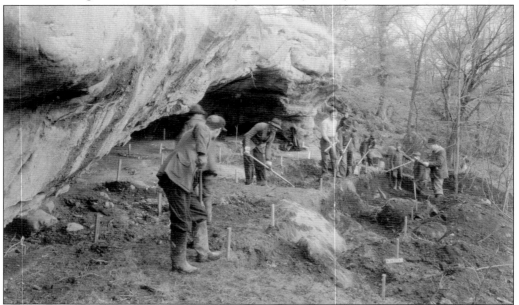

Many Native American inhabitants along the Green River lived in rock houses or rock shelters. This photograph shows the grids that archaeologists had set, which allowed for each item to be catalogued and its location recorded. The labor was conducted by WPA workers. (University of Kentucky Library.)

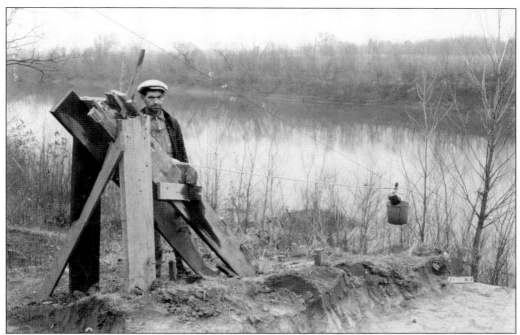

One excavation site above the Green River in Butler County required water for the excavation process. Above, a WPA worker stands next to the cable hoist system used to lift water out of the river. Below is an excavated Native American mound, with items photographed and cataloged. Under the direction of archaeologists from the University of Kentucky, WPA workers not only excavated the mounds but then returned the soil to its previous elevation. Thousands of artifacts recovered along the river mark this valley as having some of the highest numbers of Native American settlements of any river in Kentucky. (Both, University of Kentucky.)

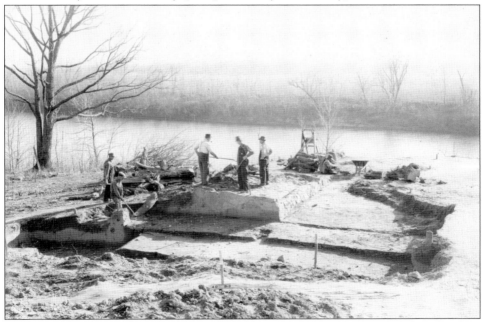

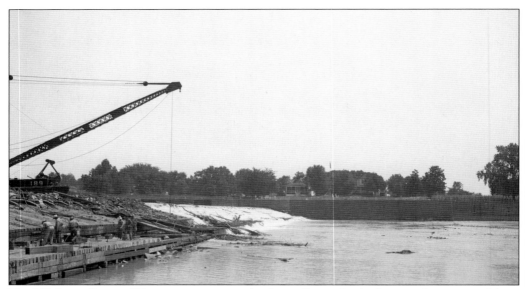

The US Army Corps of Engineers maintained a fleet of boats for dredging and removing debris. Shown is a dredge boat with a crane working on Lock and Dam 2 at Calhoun. Lock and Dam 1 and 2 were rebuilt in the 1950s, while others dated to the 1800s. All were in constant need of repairs and maintenance. (National Archives.)

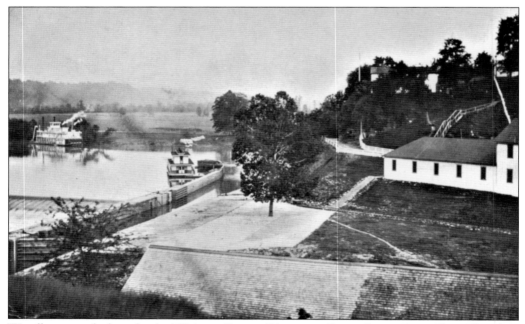

Woodbury was the base for the US Army Corps of Engineers Green–Barren River Fleet. The white house partially visible on top of the hill was the original lockmaster's house built in 1838. The large white building on the right was the government warehouse and workshops. Today, the warehouse is gone, and the original lockmaster's house is a private residence. (Green River Museum.)

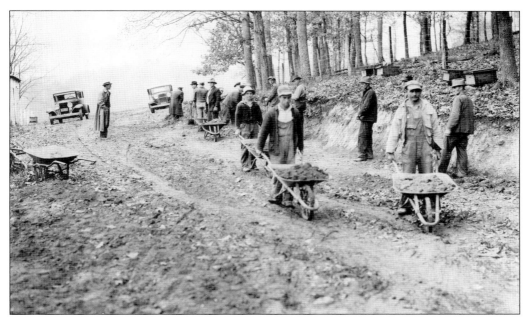

The WPA put thousands of people to work across the United States during the Great Depression. Its projects ranged from massive dams and schools to small efforts such as the one shown here in October 1935, with workers rebuilding the road to the lockmaster's office at Lock and Dam 6 at Brownsville. (US Army Corps of Engineers.)

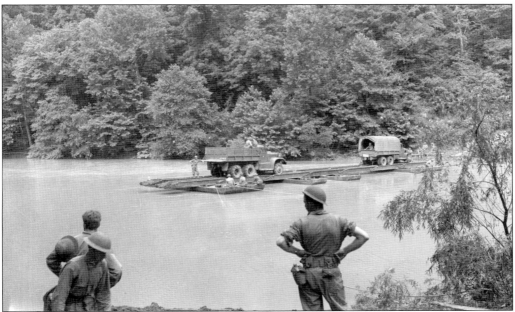

During the summer of 1941, six months prior to the bombing of Pearl Harbor, which thrust the United States into World War II, a US Army Engineer Battalion was practicing the construction of pontoon bridges needed for rapidly moving troops and equipment across rivers. This photograph shows a pontoon bridge with two trucks being cable-towed across the Green River near Mammoth Cave. (Open Parks Network.)

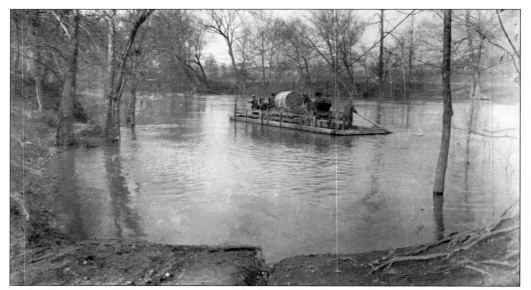

In the Green River Valley, it was not until the late 1930s that motorized ferries were used. Prior to that, cable ferries such as this one near Greensburg around 1900 required not only the ferry crew but everyone aboard to "pull their weight" to cross the river. The large barrel on board is a hogshead likely containing tobacco. (Larry Smith.)

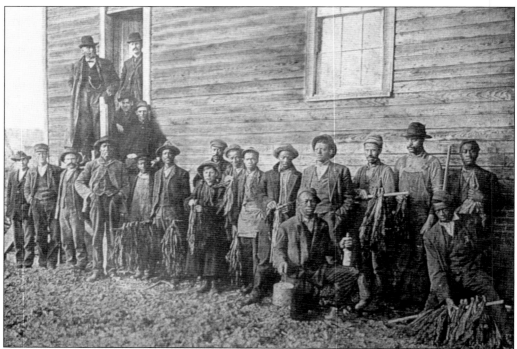

Massie Tobacco Factory workers are shown here in 1900. Many towns along the Green River had tobacco factories that purchased tobacco from local farmers and manufactured smoking tobacco, chewing tobacco, cigars, and other products. In 1916, the *Owensboro Messenger-Inquirer* reported that farmers were being paid around 9¢ per pound for burley tobacco. (Holly Johnson.)

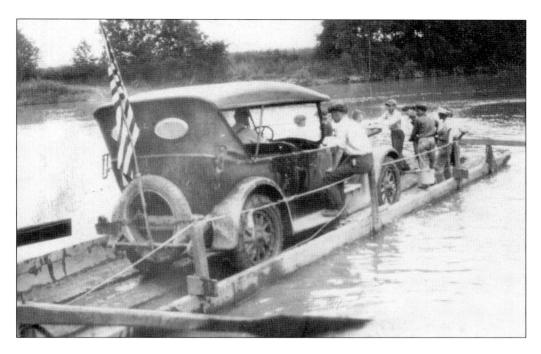

On hand-pulled ferries before the 1930s, one person would man the paddle while others pulled. In the 1920s, gravel roads, much less paved roads, were nonexistent throughout the Green River Valley. In these images, a car (appearing to be a 1923 Ford Model T) is shown onboard a ferry and being pulled up the riverbank by a team of mules. This crossing is believed to have been between Muhlenberg and Ohio Counties. (Both, Richard Hines.)

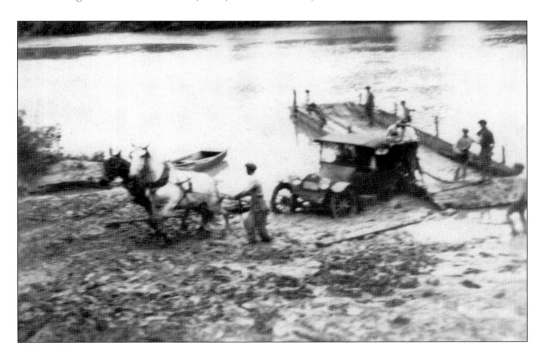

This photograph of the Woodbury Ferry was taken from the wall on Lock 4 in 1947. Except for railroad bridges, there were no bridges over the Green River until 1928. Dozens of small ferries operated along the river carrying horses, wagons, vehicles, and passengers. (Photograph by Richard Hines Sr.)

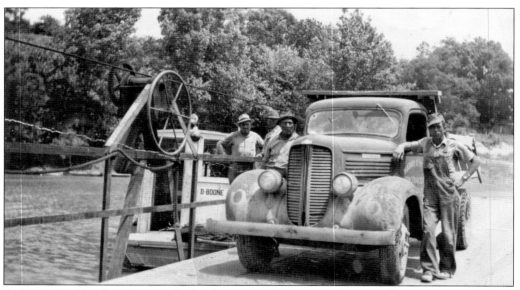

By 1950, the Aberdeen Ferry in Butler County was being towed by a small motor craft called the *D. Boone*. A few years later, this ferry was closed when the new bridge opened on US Highway 231 nearby. Pictured from left to right are Floyd Noble, unidentified, Buck Cannon, and Elmer Embry. (Green River Museum.)

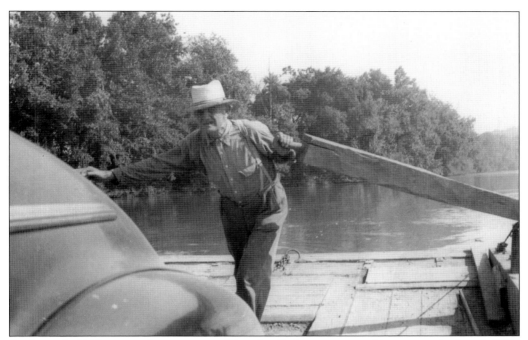

By the early 1940s, many ferries were still hand-pulled or were towed by a motorized craft. This ferry in Aberdeen was still using paddling and pulling cables to cross the river. (Western Kentucky Special Collections.)

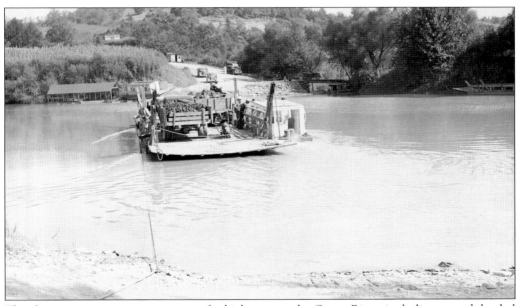

This ferry is carrying an assortment of vehicles across the Green River, including a truck loaded with "block coal" sold for heating homes and businesses and brought from smaller independent coal mines. Major coal mines in counties in the western end of the valley furnished coal to larger corporations; this coal was shipped by barge or railroad. (Open Parks Network.)

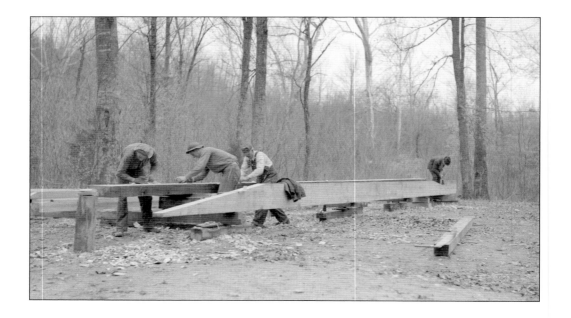

Civilian Conservation Corps crew members are shown building a ferry. At one time, Ohio County had at least nine in operation. It was not unusual to have around 10 ferries operating in every county along the river. Below, a CCC crew is installing a motor drive on a newly constructed ferry near Mammoth Cave. There were once a dozen ferries near the cave. (Both, Open Parks Network.)

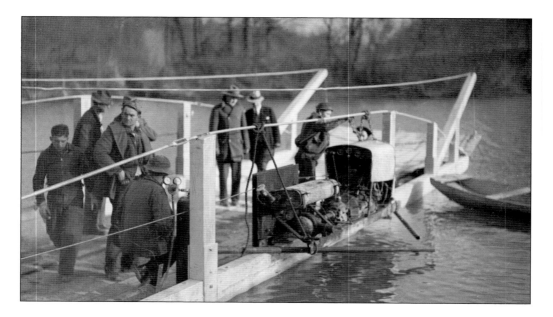

This CCC crew is moving a newly constructed ferry down the Green River to a location near Mammoth Cave. (Open Parks Network.)

In 1970, Rangers Landing was the last ferry between Henderson and McLean Counties. It had been operated by ferry master O.B. Kirtley for 23 years. The fare was 75¢ for cars and $1 for trucks. In 1969, the 160-year-old ferry ceased operations. By the 1970s, most ferries had closed. Four remained in operation along the Green River in 2023. (McLean County History Museum.)

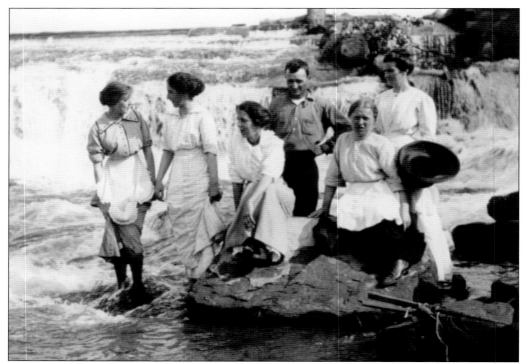

A group of women cool their feet at Rochester Dam. The dam has always been a popular location for picnics and family outings. It appears one of the people pictured had been fishing in the waters below the dam. At bottom right is a minnow seine, which is used to catch minnows and other small baitfish. (Barry Duvall.)

Seen here is the Rochester loading site at the Mud River's confluence with the Green River. Across the river is the lockmaster's home at Lock and Dam 3. This photograph was taken by one of the family members of Schroeter Studios in 1908. The Schroeter family not only photographed families but also documented events and scenery along the rivers. (Western Kentucky University Special Collections.)

Four

LIFE IN THE GREEN RIVER VALLEY

Life in the Green River Valley involved hard work, but residents also enjoyed the river and all it had to offer. Thanks to the lock and dam system, the steamboat era was perhaps the most spectacular of any period, with many passengers moving along the river each day. In many respects, trips at that time were like the riverboat tours offered today. Passengers came for the spectacular views the river had to offer.

As trains began replacing steamboats in the early 1900s, river jobs began disappearing. Ironically, many of the products shipped out of the valley by barge were directly helping with the demise of the steamboat industry. In one year, over one million railroad ties were shipped out of the valley for use in the construction of railroads.

Mining began to decline in the 1980s and 1990s, but lands that were owned by Peabody Coal Company, one of the world's largest strip-mining operations, are now part of Kentucky's largest wildlife management area, which provides visitors with myriad opportunities for outdoor recreation.

The upper section of the river is one of the most biologically diverse areas in the United States because of the number of species of fish, mussels, and crawfish that inhabit it.

Much as it once did, commercial river traffic continues to ply the river's emerald-green waters along the lower 100 miles.

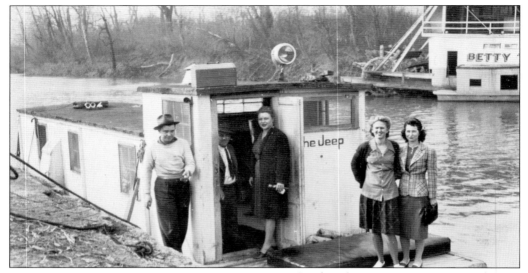

Sunday afternoon visitors pose on the small tender *The Jeep* moored next to the *Betty Turner*. From left to right are Tommy Melton, unidentified, Mary Melton and two unidentified women who were visiting the boat. *The Jeep* worked the port and wharf area around Bowling Green on the Barren River shuttling supplies and equipment. (Marilann Melton and Courtlann Atkinson.)

Sunday afternoons during the summer were spent on the river. Here, Shirley Edwards and Ida Heltsley Edwards from Powderly are posing for a photograph at the South Carrolton Landing in the summer of 1920. There are steps nailed on the tree behind them and a rope for swinging into the river, which was customary at every swimming hole along the river when water levels were higher. (Richard Hines.)

Shirley Edwards is believed to be on the paddle wheel of the packet *Bowling Green* shortly after it was forced onto the bank on the Ohio County shoreline in March 1920. The boards used on the paddles of paddle wheelers were not that substantial, and extra lumber was kept on board for minor repairs when the paddlewheel hit a log or other obstruction. (Richard Hines.)

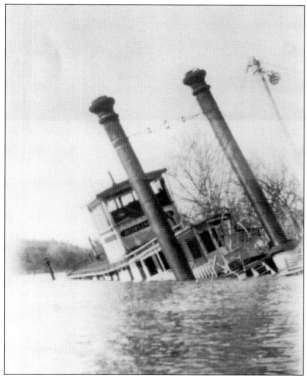

The steamer *Bowling Green* is pictured after sinking up to its Texas deck across the river from the South Carrolton landing. Because the water at the landing was over 100 feet deep, Pilot Jones ran the vessel across the river in an attempt to "run her up in the cornfield." All passengers managed to safely get off the boat, and it was said to have been a miracle that no lives were lost. (Western Kentucky University Special Collections.)

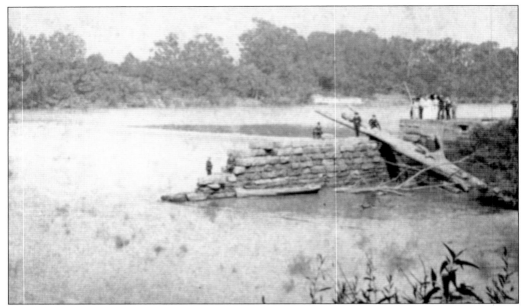

This image shows people enjoying the falls at Spottsville. Regular excursions were made to Spottsville from Evansville. In June 1882, an advertisement in the *Evansville Courier and Press* promoted a five-hour journey up the Green River to Spottsville on the *Hotspur and Barge Twilight* for just 25¢. (David L. Rice Library University of Southern Indiana.)

Every weekend, pleasure boaters and anglers launch boats on the Green River. This boat was being launched at the ramp in Calhoun around 1965 for a day out on the water. Until the 1970s, there were few boat ramps along the river, but thanks to the Kentucky Department of Fish and Wildlife, there are now dozens. (McLean County History Museum.)

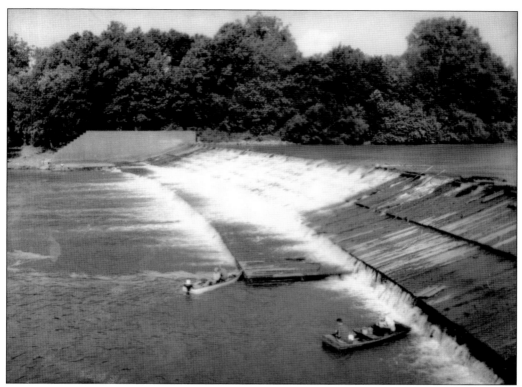

Anglers are pictured in boats fishing below Dam 4 at Woodbury. During low water flows, fishermen were able to pull their boats up close to the dam and tie off to the wooden cribbing, where they could catch fish such as walleye, bass, crappie, and catfish. The cribbing allowed water to flow over the dam without creating undercutting that would weaken it. (Green River Museum.)

Willard Parnell poses with his record muskellunge, or muskie, from Green River. This unusual fish is found along the upper stretches of the river and is known as "the fish of 10,000 casts" because of the difficulty in catching them. Parnell is the only person known to not only catch a state record muskie, but later break his own record, which he did with this fish in January 1970. (Willard Parnell.)

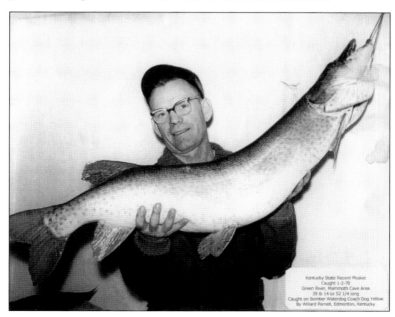

Above, waterfowl hunters at Woodbury pose after a successful hunt. During the winter months, waterfowl hunting is a popular pastime for residents along the Green River, particularly when the river is at flood stage, as the backwater is pushed into the surrounding river bottoms and sloughs. Flooding in the winter creates the perfect conditions to attract migrating waterfowl to the river bottoms. Below, the towboat *New Hanover* is shown with a crew and several of their English setter bird dogs on deck. Most rivermen were avid hunters and fishermen, and after 20 days on the boat, a day of quail hunting was a nice break. Typically, towboat crews worked nonstop for two to three weeks before going home. (Both, Marilann Melton and Courtlann Atkinson.)

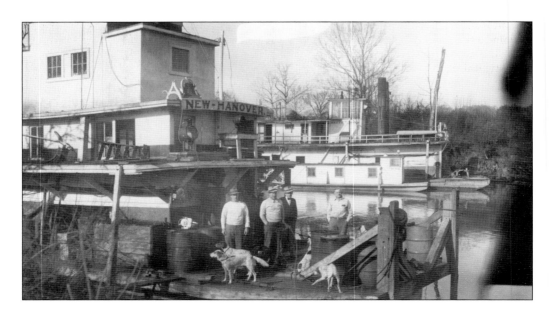

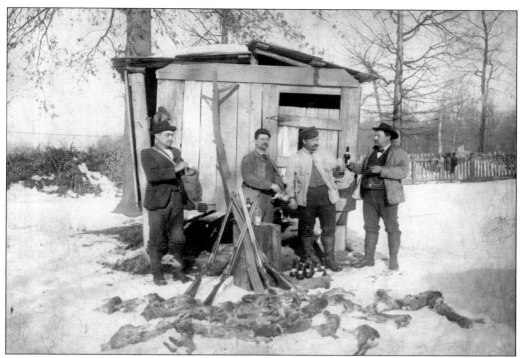

A group of men celebrate after a successful day of rabbit hunting along river bottoms in Henderson County. Hunting was not only a popular pastime, but rabbits, quail, and squirrels supplied meat to families. A man named Mr. Frazier would tell of having a couple of big rabbit hunts every winter along the Green River and feeding everyone in the neighborhood. (University of Southern Indiana.)

A man is shown running a trapline along the river. This was a typical sight along the Green, where rivermen made their living. Every year, they trapped from November through January, when fur was its best quality. During the spring, summer, and fall, rivermen would harvest catfish using trotlines or nets, supplying them to residents and restaurants. (Marilann Melton and Courtlann Atkinson.)

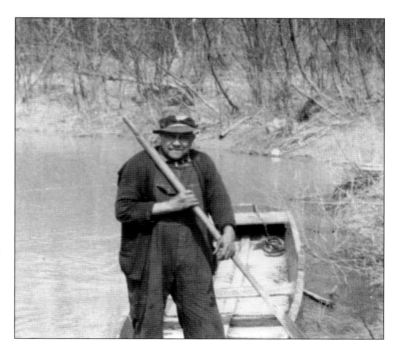

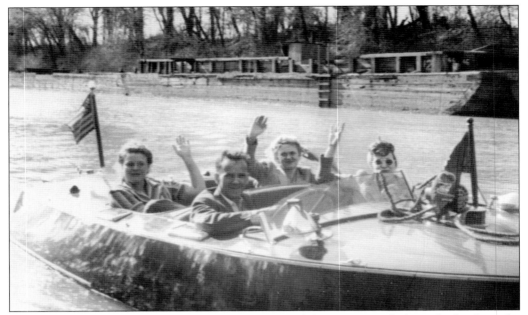

These people are boating along the Green River with barges moored along the bank in the background. From the 1930s through the 1940s, most runabouts (or motorboats) were made of wood. Chris-Craft and Dart were two popular brands. After World War II, excess aluminum became available for the construction of boats; the aluminum came from the large numbers of surplus military aircraft. (Marilann Melton and Courtlann Atkinson.)

Boating was a regular summer activity for youth in the Boy Scouts of America. One of the Boy Scout merit badges was for boating, which required the boys to make a long trip with each of them taking turns operating the motor, rowing, handling navigation, practicing lifesaving skills, and other tasks. The Green River provided a location for this each summer. (Open Parks Network.)

Quay Coffman from Livermore is pictured in his homemade 24-foot inboard boat. Coffman built this boat in the 1930s from blueprints purchased from a *Reader's Digest* magazine. The boat was built out of cypress that he cut himself and was powered by an engine from a Ford Model A. Coffman took doctors to sick people, responded to emergencies, and even delivered nitroglycerin to oil drillers during floods. (Frank Coffman.)

In 1938, runabout motorboats were uncommon, and the rangers at Mammoth Cave (prior to the cave becoming a national park) gave rides to people on the river. This boat was owned and operated by the Civilian Conservation Corps near one of the ferries and was referred to as the "CCC Motor Launch." It is believed to be a Dart Runabout. (Open Parks Network.)

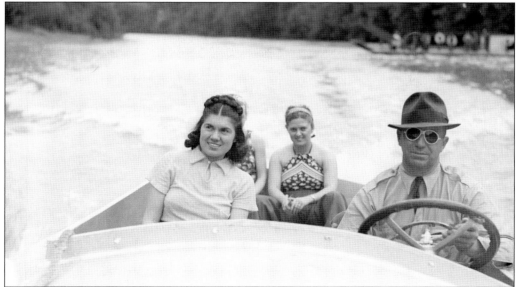

Throughout most of the summer months, weekends were a time of fun around the river, especially at dams. Here, Hilda Melton Hines is enjoying an afternoon of swimming on the Woodbury Dam, where people congregated around the sand and gravel bar just below the lock chamber. In late summer, when the river was low enough, swimmers could go out on the dam. (Tommy Hines.)

Summer days were hot, so wherever people could access the river, there was swimming on sandbars and at the beaches. Frank Coffman said, "There was a swimming hole at the old Livermore Landing at First and Main Streets. It seemed there was not a day kids were not in the river on that pebbly beach." This was originally the old steamboat landing where James Livermore had his trading cabin. (Frank Coffman.)

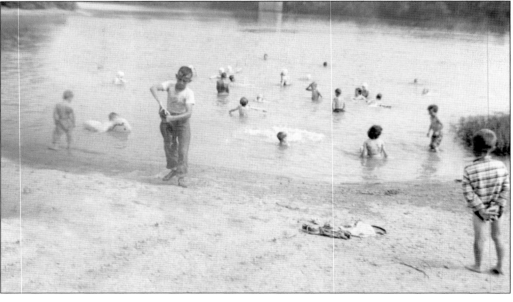

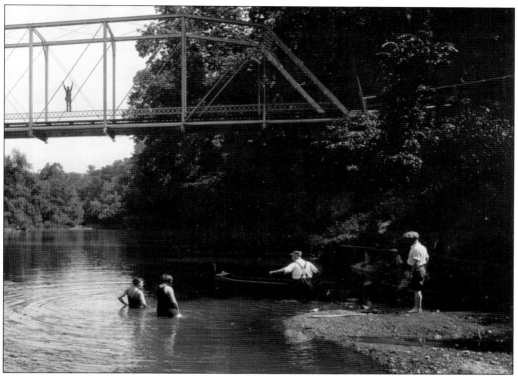

The upper end of the river is much shallower, but still attracted swimmers on a hot afternoon, as shown here near the Green River Bridge at Liberty in 1930. Metal truss bridges such as this one were the most common type of bridge along the upper stretches of the river. (National Archives.)

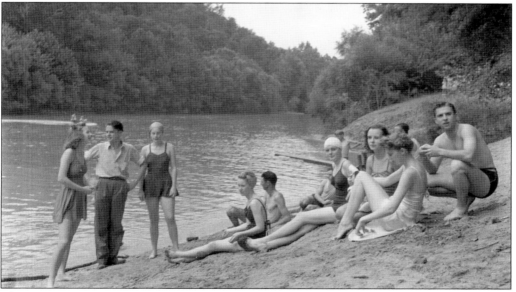

This group of swimmers took advantage of the sandbar near Mammoth Cave along the Green River during the summer of 1938. Every sandbar along the river was occupied by swimmers throughout the summer months. Mammoth Cave maintained a swimming beach. (Open Parks Network.)

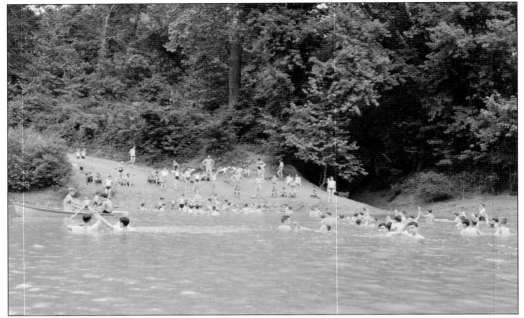

The Boy Scouts of America held annual summer camps along the river. Scouts learned canoeing, rowing, and—most importantly—swimming. Advanced scouts learned lifesaving and first aid, which are still taught at summer camps. In this photograph, lifeguards have called for a "buddy check," which teaches scouts to keep watch for each other and never swim alone. (Open Parks Network.)

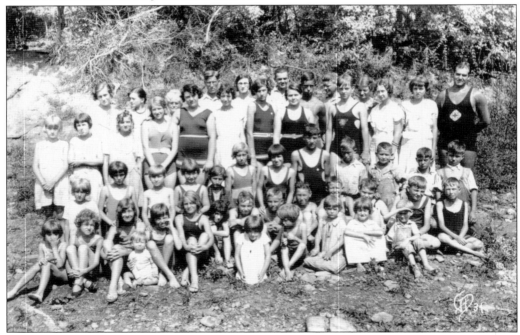

The American Red Cross held swimming classes in the Green River, since swimming pools were almost nonexistent throughout the Green River Valley. This swimming class was held in Morgantown in 1931. Older and more experienced swimmers also learned lifesaving skills. (Green River Museum.)

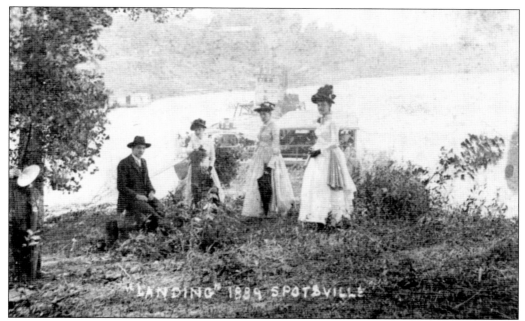

Pictured here is a picnic at the Spottsville Dam and waterfalls around 1890. Spottsville was named for Samuel Spotts, who purchased the land around 1830, when the first lock and dam was constructed on the Green River. The dam has since been upgraded. (David L. Rice Library University Archives and Special Collections at the University of Southern Indiana.)

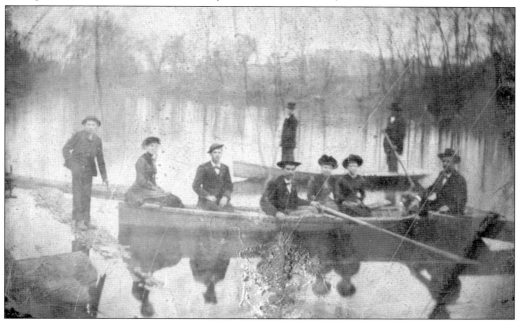

The Burchfield family is pictured on a weekend river outing sometime in the late 1890s or early 1900s. It was common for people to dress formally even on weekend outdoor excursions because it was a pleasure to not wear work clothes, as they did throughout the week. Casual clothing was uncommon during this era. (Western Kentucky University Special Collections.)

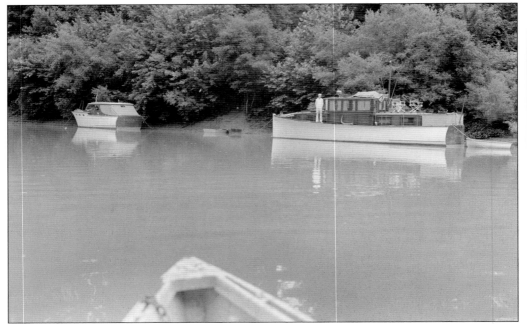

Large boats called cabin cruisers would travel the river and anchor at landings near Mammoth Cave. These two boats are marked as being ported in Louisville. This trip would have included approximately 210 river miles from Louisville down the Ohio River to Henderson County and up the Green River through six locks for another 175 miles. (Open Parks Network.)

Most camping along the Green River was primitive, but those staying in Mammoth Cave—even prior to the area becoming a national park—had access to high-quality campsites equipped with fireplaces, tent pads, and picnic tables. One of the prime attractions of the park was not just the cave but also the activities along the river. (Mammoth Cave National Park.)

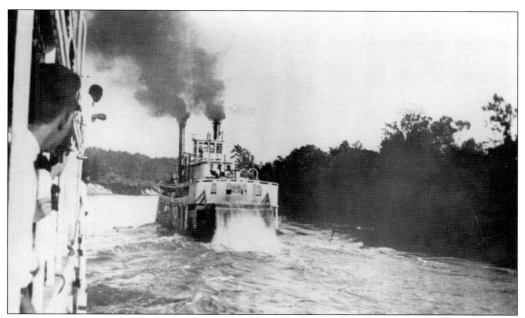

This photograph was taken by George Dabbs on the Green River and is titled "Steamer Bowling Green on down trip passing steamer Evansville on up trip above Calhoun early 1900s". George Dabbs (1882–1967) was a commercial photographer from Morgantown who took hundreds of photographs, and is credited with singlehandedly preserving much of the history of the Green River. (Cincinnati and Hamilton County Library.)

The Brownsville Lock and Dam 6 lockmaster and assistant lockmaster houses are pictured around 1907. The US Army Corps of Engineers built identical residences for its staff at each lock and dam. Lockmasters were responsible for all operations, which required that someone be available to open the lock gates allowing boats to move between pools at any time, 365 days a year. (Mammoth Cave National Park, James Skaggs Collection.)

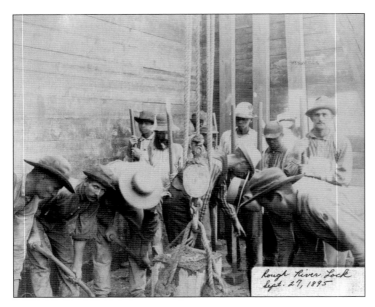

In 1895, navigation was extended on the Rough River, one of the tributaries of the Green River. Here, a crew is working in the newly constructed lock chamber that extended boat service from Livermore to Hartford. Around the same time, Congress debated appropriations to extend navigation to Greensburg and the Little Barren River, but without success. Only the Barren and Rough Rivers had locks and dams constructed. (National Archives.)

Rough River Lock Sept. 27, 1895

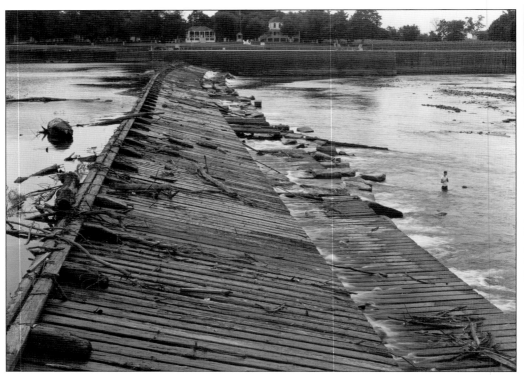

A fisherman is shown below Lock and Dam 2 in 1954. During low-water conditions, many people came to fish at the dams. During the early spring, white bass (called stripes) would run and hold just below the dam. During the summer months, bass, catfish, and crappie would be biting. Fish were always in the deeper pools waiting for food to come over the dam. (McLean County History Museum.)

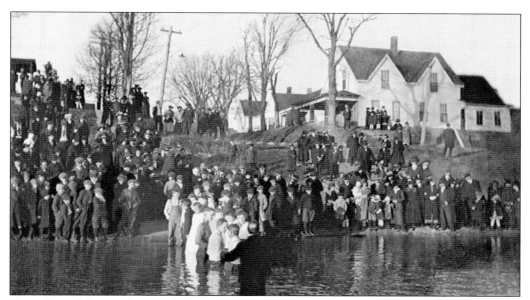

Regardless of the weather conditions, baptisms were common in communities along the Green River. Here, worshipers are watching a group of church members after they waded into the river to be dunked as part of the baptism process. The baptism shown here took place at the end of Main Street in Livermore around 1929. (Holly Johnson.)

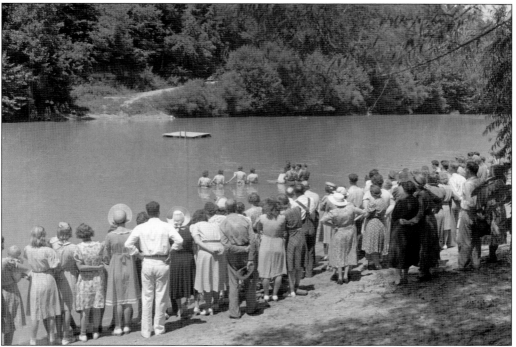

From the late 1700s until the present, thousands of Christians have been baptized in the Green River. Large numbers of people from local communities would attend. These baptisms were held from the smaller reaches of the river in Casey County to the mouth near Henderson. This baptism was held somewhere in Edmonson County. (Mammoth Cave National Park.)

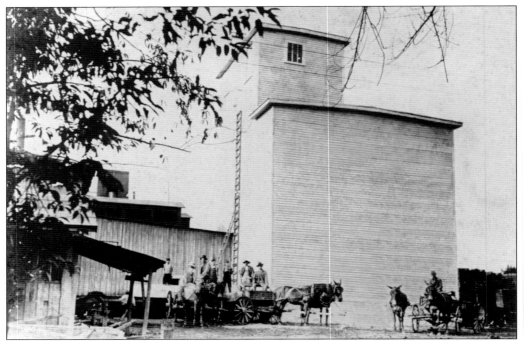

Icehouses were found in every town along the river. Until the 1920s, ice was cut and harvested from either the river or local ponds each winter and stored in sawdust in buildings such as this one in Livermore. Wagons made daily deliveries of ice to homes. Riverboats would fill their iceboxes at each stop to keep items cold for river trips. (Holly Johnson.)

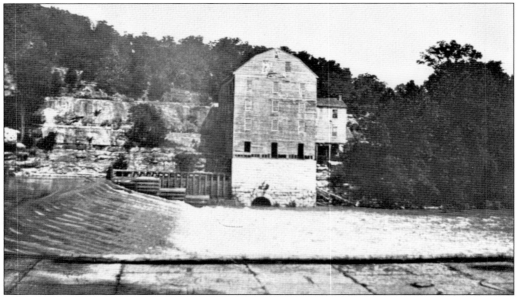

Barren River Lock and Dam 1 was an important link from Green River that allowed travel to Bowling Green. Browns Mill was on the side of the river adjacent to Barren Lock and Dam 1, which was called Browns Lock and Dam for many years until the old mill was eventually abandoned and fell into disrepair. (Western Kentucky University Special Collections.)

Farming was the primary occupation of most residents along the Green River. The above photograph shows Walton Hines combining soybeans in the river bottoms in Butler County around 1947. The tractor was a 33-horsepower 1946 Oliver Model 70 Row-Crop, pulling a John Deere 12-A combine that was not self-propelled. The combined soybeans went into a hopper that was emptied into bags after each round; the hand-tied bags are visible on the ground below. The bags were loaded onto trucks and hauled to market. During the 1940s, Butler County farmers averaged around 16 bushels of soybeans per acre, which brought $2.02 per bushel. Thanks to improved technology and equipment, farmers throughout the valley now average around 51 bushels of soybeans per acre. (Both photographs by Richard Hines Sr.)

Whitakers Opera in Livermore is pictured above during the run of a show in 1910. Livermore was once a thriving town with around 1,500 residents; among the many businesses was an opera house. As businesses developed to take advantage of the large amount of timber being floated down the river, rivermen stopped in town to eat, stay in a hotel, and attend plays and operas. Below, a wagon is picking up supplies from a boat at the Livermore landing. In the background is the Livermore railroad bridge, which was constructed in 1871–1872 for the Owensboro & Russellville Railroad at a cost of $106,000. It was later used by the Louisville & Nashville Railroad. The swinging bridge was dismantled in 1988. (Both, Holly Johnson.)

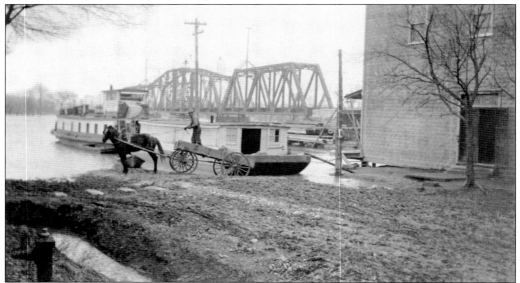

Woodbury is seen here during the 1913 flood. The Louisville *Courier Journal* reported that the 1913 flood was the greatest in history, with heavy loss of livestock and property. For 200 miles upstream and throughout the river valley, hundreds of displaced residents were cared for by neighboring communities. Up until 2022, the 1937 flood surpassed all others in size, damage, and loss of life. (Green River Museum.)

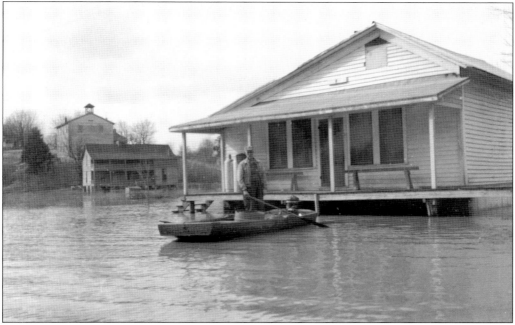

The 1957 flood in Woodbury did not reach the levels of the 1913 or 1937 floods. In this image, the former office of Dr. Elwood Wand is being checked by Esker Carroll, who was a local commercial fisherman. The tall building on the hill in the background contained the Methodist church on the lower floor and Woodbury Masonic Lodge 280 on the upper floor. (Green River Museum.)

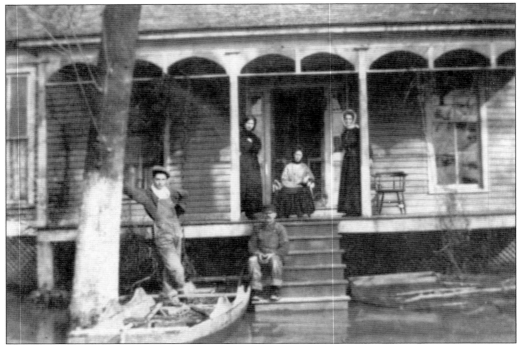

This photograph taken during the 1913 flood shows a Rochester house being visited by a neighbor. Green River Valley towns suffered major floods in 1913 and 1937. The emergency services people are accustomed to today were nonexistent then, and those who made a living on the river, such as trappers and fishermen, were the ones who came to the aid of their neighbors. (Green River Museum.)

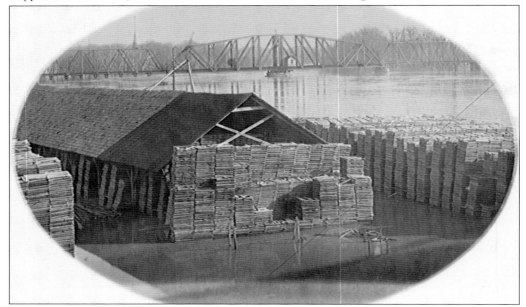

Quigg Brothers Pallet Mill in Livermore is pictured during the 1913 flood. This was one of numerous businesses that developed along the river to take advantage of the large number of logs being floated down it. Pallets were used to secure freight during shipment. (Holly Johnson.)

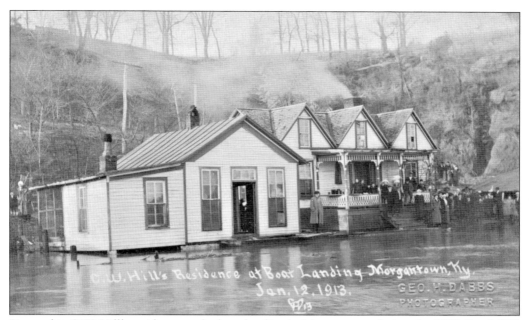

Pictured is C.W. Hill's residence at the boat landing in Morgantown during the 1913 flood. Hill was the wharf agent and lived here with his family. With one of the larger watersheds in Kentucky, the Green River has always been susceptible to flooding, and those who lived and worked on the river were accustomed to periodic floods. (Green River Museum.)

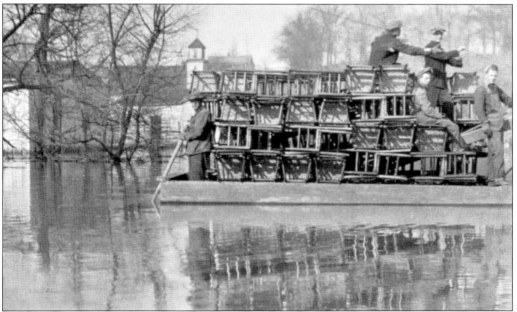

In 1933, the Green River Chair Company and Livermore Chair Company employed almost 500 men to turn wood on lathes, assemble chairs, and finish frames. After the chairs were completed, they were delivered to homes across town so women could weave seats or cane for straight-back and rocking chairs. This photograph shows chairs being retrieved from porches during a flood. (Holly Johnson.)

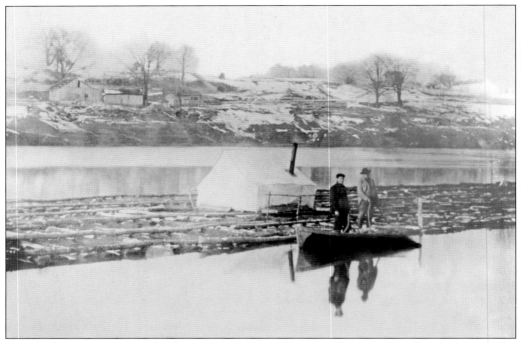

Most high-water events on the Green River occurred between late winter and early spring. This raft is passing Livermore sometime during the winter, with snow on the shore. Tents like the one shown here were equipped with stoves to keep them warm at night. Log rafts could be as long as 300 feet and as wide as 65 feet, and they were put together in sections called batches. (Holly Johnson.)

Rochester Dam is pictured during a flood in 1965. In the background is the lockmaster's home. Although it was extremely dangerous, during floods like this one, log raftsmen would shoot the falls, taking rafts over the dam to either save time or avoid having to pay a lock fee. If they did have to use the locks, log rafts would have to be broken into batches, floated through, then reassembled downstream. (Photograph by Richard Hines.)

Sloughs and side channels are an important component of any river system. There were hundreds of these sloughs, which are created by overbank flooding, along the Green River floodplain. Typically, the areas were too wet to farm, but they provided a natural overflow area used by fish and wildlife throughout the year. By the 1970s, many of the sloughs had been drained and cleared for agriculture along the lower river. (Photograph by Richard Hines.)

Flooding was the enemy of farmers, and dredging and channelization of smaller stream tributaries such as Pond Creek in Muhlenberg County began in the late 1920s and continued through the 1950s. It was thought that straightening the creeks would move water out of the bottomland faster, but it only served to increase erosion, filling the Green River with tons of sediment. (University of Kentucky Special Collections.)

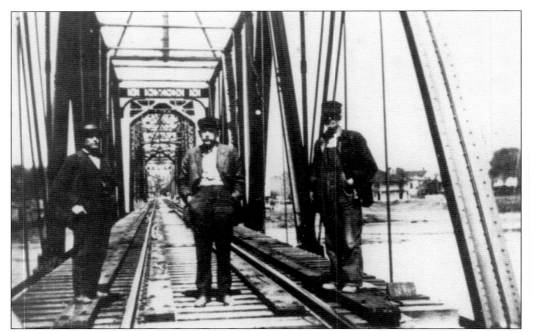

These workers are standing on the Livermore swing bridge. The bridge was required to always keep a crew on-site to open it for boat traffic. When the bridge was open, signals were in place to notify oncoming trains to stop. (McLean County History Museum.)

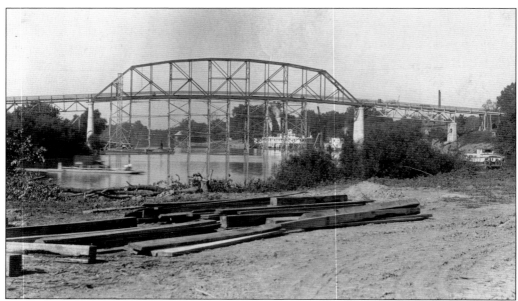

During construction of the 1,050-foot-long bridge connecting Calhoun and Rumsey, supports and piers were required to temporarily hold up the bridge, preventing the passage of boats. As boats approached, passengers were required to get off and walk to the next boat either above or below the bridge. Completed in 1928, it was named the James Bethel Gresham Bridge. (McLean County History Museum.)

Local officials check on the progress of the James Bethel Gresham Bridge. James Gresham, a McLean County soldier, was the first American killed in France during World War I. The bridge required a toll until 1944 and was demolished in June 2000 after a larger bridge was completed next to it. (McLean County History Museum.)

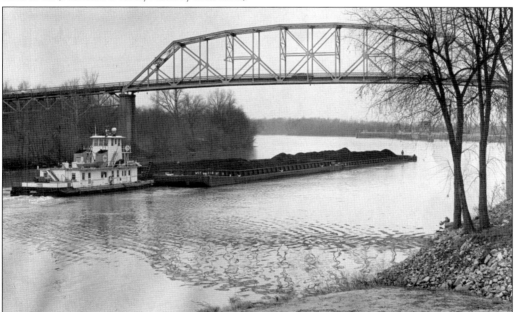

The towboat *Annabel*, downbound with barges, passes under the Gresham Bridge at Calhoun. *Annabel* was operated by the Crounse Corporation, which began operations on the Green River in 1956 after other towing companies slowed operations and Locks 1 and 2 were upgraded. Coal was moved down the Green River daily to electrical plants and industrial customers on the Tennessee, Cumberland, Ohio, and Mississippi Rivers. (McLean County History Museum.)

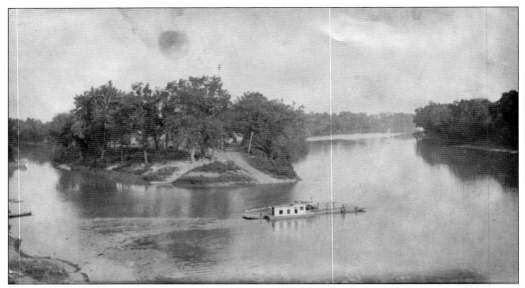

The Livermore Ferry began operations in the early 1800s, crossing both the Green and Rough Rivers. The ferry would drop people off in Ohio or McLean County on both sides of the Green River. It was part of Kentucky Route 75 in 1929 and was in operation until the US Highway 431 bridge was completed in 1940. (McLean County History Museum.)

The Livermore Highway 431 bridge was dedicated by Gov. Keen Johnson in 1940, eliminating the Livermore Ferry. It is considered one of a kind, since it begins and ends in the same county (McLean), while crossing two rivers (Rough and Green) and another county (Ohio County). It was featured in *Ripley's Believe it or Not!* (Photograph by Richard Hines.)

The entire community showed up for the dedication of the Berry Bridge in Green County in 1908. The bridge was deemed unsafe in 1981, but remains standing as of 2023. It was built by the Champion Bridge Company of Wilmington, Ohio. This design is called a pinned camelback through truss. (Larry Smith.)

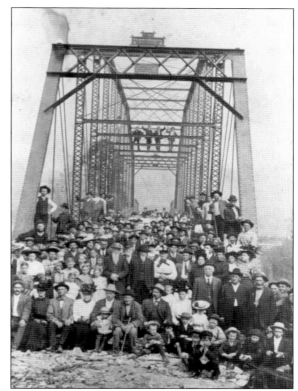

The Tebbs Bend Bridge, which connected Campbellsville and Columbia, is shown during a flood in the 1960s. Although many metal truss bridges appeared flimsy, they were well constructed and survived numerous floods. Built by the Vincennes Bridge Company in 1907, this 165-foot bridge was replaced with a stronger truss bridge. The original was preserved and moved to the adjacent Tebbs Bend Battlefield Park in 2015. (Larry Smith.)

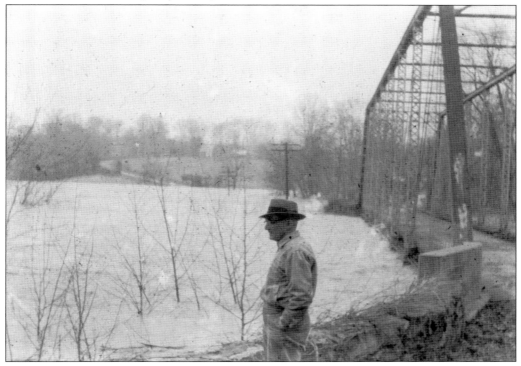

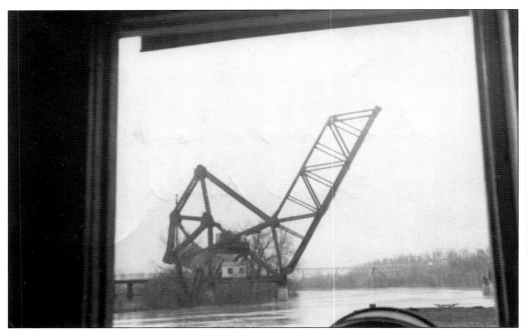

Pictured here is a view from the pilothouse of the towboat *New Hanover*. The Rockport (Small House) Bridge is a bascule bridge, meaning it is moveable and has a counterweight that continuously balances a span during the upward swing, allowing boats to pass. Built by the Virginia Bridge Company in 1931 for the Illinois Central Railroad, it is still in use by the Paducah & Louisville Railway. (Marilann Melton and Courtlann Atkinson.)

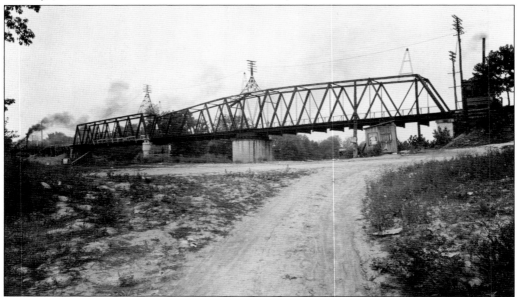

The Louisville & Nashville Railroad bridge at Rockport was built in 1870 and was a turntable or—more appropriately—a swing bridge. It was replaced in 1931 for the Illinois Central Railroad with a lift bridge that is still in use today. A steam-powered shovel is working in the left background. (National Archives.)

This photograph was taken by the US Army Corps of Engineers in August 1930 and shows the bridge built by the Southern Railroad over the Green River. The adjacent landowner constructed a split-rail fence across a portion of the river to allow cattle to reach a pool of water in the dry riverbed under the bridge near the community of McKinley in Lincoln County. (National Archives.)

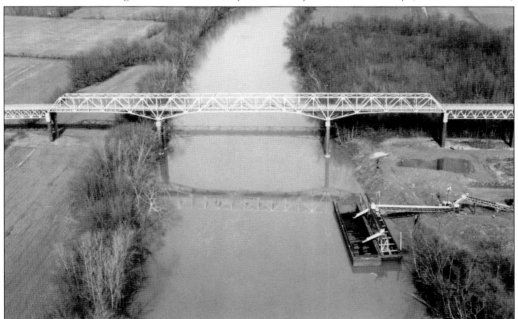

There were numerous barge-loading terminals along the Green River, including this one near the Rockport bridge in May 1974. Coal was moved on conveyor belts from nearby mines and loaded onto barges through the two chutes above the barge. The Rockport bridge connects Rockport in Ohio County with neighboring Muhlenberg County via US Highway 62. (US Army Corps of Engineers.)

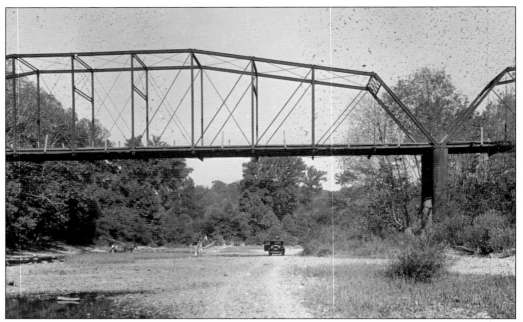

This photograph of the Green River Bridge near Greensburg in August 1930 shows a 1920s Ford Model A parked in the riverbed. On the upper portion of the river during late summer when the water was low, it was customary to drive onto the riverbed to fish and swim, or, in the case of the wagon seen at left, fill a water barrel. (National Archives.)

Approaching the source of the Green River in Lincoln County, the river appears to be merely a small creek during August 1930. This wooden bridge was called the McKinley Bridge and at the time served a small county road. The man on bridge was an inspector certifying bridges along the river. (National Archives.)

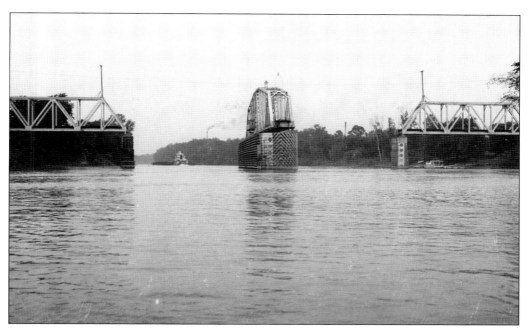

This was the Louisville & Nashville Railroad's bridge over the Green River at Livermore in June 1967. The bridge had a full-time tender on duty to swing the bridge open to allow towboats to pass—including the one seen here, which has just cleared the bridge. (US Army Corps of Engineers.)

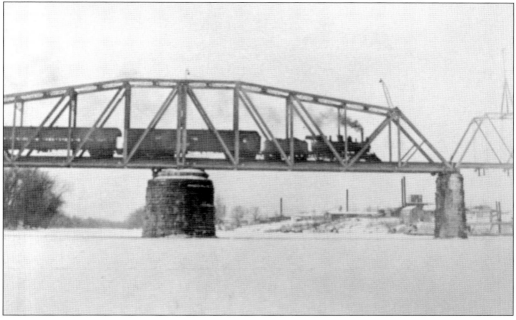

A Louisville & Nashville Railroad passenger train crosses the closed Livermore swing bridge. Engineers were required to blow their train whistle as they approached the bridge, indicating they saw the signal lights. White lights meant go, while red lights signaled stop. At Spottsville in 1904, freight train 64 ran through red signal lights, with the engineer whistling he had observed the white lights moments before the train crashed into the river. (McLean County History Museum.)

Everything that occurs within the river's watershed eventually affects the river. However, in some cases, if a spill was only coal, as in this wreck, it was not as detrimental to the stream as oil or other such products could have been. Here, Mac Bray (left) and Tommy Pendley view an Illinois Central Railroad wreck on a switch line into Pond Creek Mine around 1974. (Photograph by Richard Hines.)

On July 8, 1931, the Spottsville Bridge in Henderson County collapsed, falling 80 feet into the Green River and killing three workers. It could have been much worse, because only five minutes earlier, there were up to 35 men working on the bridge. The bridge was rebuilt and remained in operation for many years. (Western Kentucky University Special Collections.)

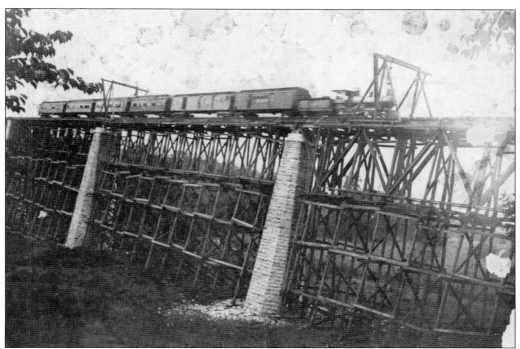

The Green River railroad bridge was built in 1859 and spanned 1,800 feet across the river valley near Munfordville. Called an engineering marvel by *Harper's Weekly* in 1860, it reduced the trip from Nashville to Louisville to only 16 hours. During the Civil War, the bridge became a target for Confederate forces and was partially burned by Gen. Simon Buckner but was later repaired by Union engineers. (Hart County Historical Society.)

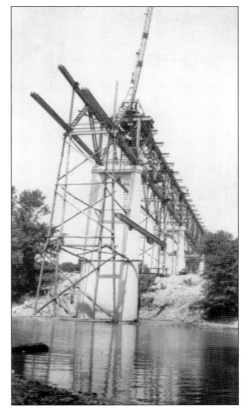

Construction of the US Highway 31W Bridge over Green River at Munfordville is pictured here in 1938. Funded by the Works Progress Administration, the bridge remains in use as of 2023. It is named the Simon Bolivar Buckner Memorial Bridge. Buckner, the 30th governor of Kentucky, was a West Point graduate who served in the US Army during the Mexican-American War and as a general in the Confederate army. (Hart County Historical Society.)

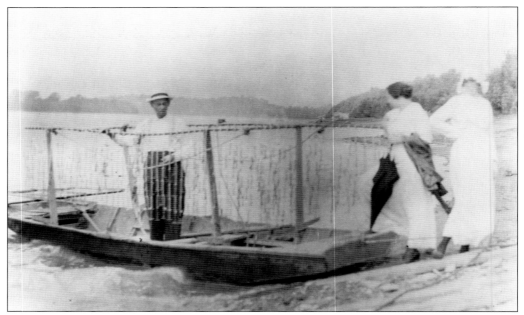

Above is a freshwater mussel "braille boat" in 1900 along the Ohio River near the mouth of the Green River. This was a typical setup for harvesting mussels in rivers, and the techniques have not changed much over the past 100 years. Below is a board equipped with a series of short chains with wire hooks, each tipped with a bead. As the board is dragged along the bottom, mussels clamp onto the bead and are lifted out of the water. Larger shells are collected, while smaller ones are returned to the river. Musseling was a summer job for many families along the Green River each year. (Above, Cincinnati and Hamilton County Public Library; below, Monty McGregor.)

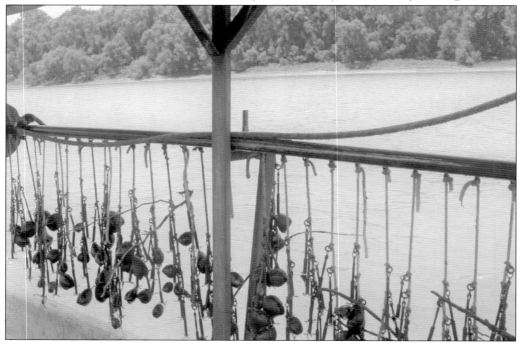

This is a shell of a white wartyback mussel. Shells were cleaned so that a punch could be used to drill out buttons, which were sold around the world. The mussel-shell industry was active for many years, but due to declines in many species, commercial mussel harvesting has not been legal on the Green River since 2005 or anywhere in Kentucky since 2015. (Photograph by Richard Hines.)

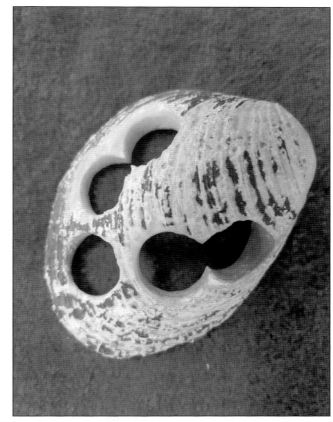

Kentucky Department of Fish and Wildlife conservation officer Jeff Finn is shown pulling an illegal hoop net out of the Green River. Commercial fishing is legal on the river, but there are restrictions. When commercial fishing gear does not meet regulations, it is subject to confiscation. Conservation officers also serve as first responders who assist the public. (Jeff Finn.)

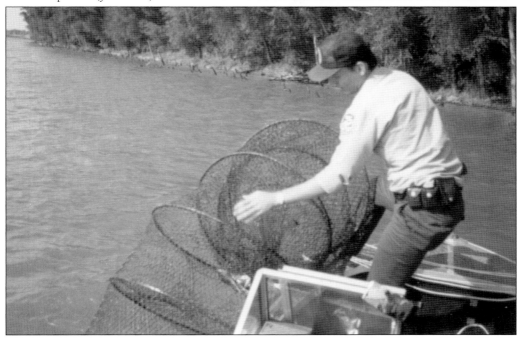

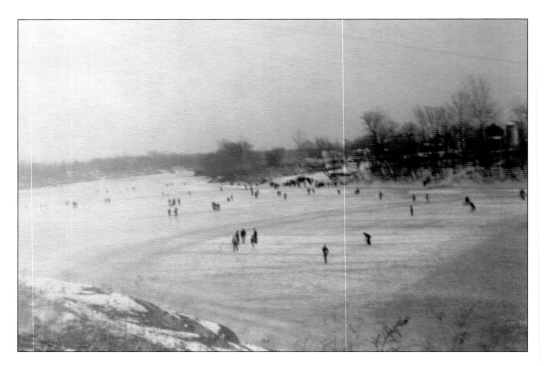

The frozen Green River hampered traffic. In 1917 and 1918, boat traffic was tied up on the Ohio and much of the Green for 40 days. In 1935 and 1936, boat traffic was suspended for 23 days, and again in 1939 and 1940. The below photograph was taken at Livermore in January 1940 and shows residents enjoying the river during a time when traffic remained at a standstill for 22 days. Green River boatmen were not bothered with ice, and said it seemed like every 10 years there would be several days with temperatures low enough to freeze the river. Most believed that the strong mineral content, depth, and swift current kept the Green from freezing. Many boats wintered in the Green River to avoid the large ice floes along the Ohio. (Both, McLean County History Museum.)

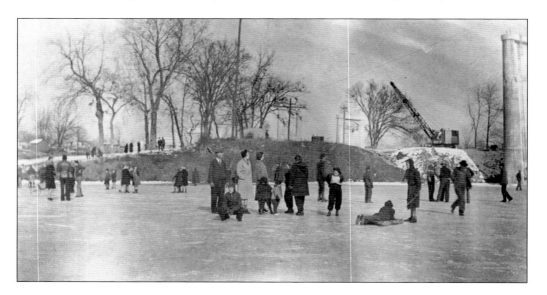

The Civilian Conservation Corps had four camps at Mammoth Cave starting in 1935, which was six years before the cave became a national park. Pres. Franklin D. Roosevelt referred to the CCC enrollees as his "CCC Boys." These CCC members are walking on the ice near Houchin's Ferry around 1935 after they had attempted to cut a trail for the ferry to cross. (Open Parks Network.)

During the winter of 1940, extremely cold weather hit Kentucky, which caused the Green River to completely freeze over. During this cold snap, numerous photographs were taken of people ice-skating and walking on the river. This image features one local pilot from Livermore who decided to land his small plane (believed to be a Piper Cub) on the frozen river. (McLean County History Museum.)

This mill site in Middleburg was constructed across the Green River in the 1800s by Christopher Riffe, who purchased the land from Capt. Abraham Lincoln, grandfather of Pres. Abraham Lincoln. Captain Lincoln had received a military warrant for 800 acres on the Green River for his service in the Continental Army in 1784. Riffe started a post office here in 1837. The mill was later called Coffey's Mill. (Photograph by Richard Hines.)

Just prior to the completion of the Green River Dam, water was pumped out of the spillway by workers and a firetruck pumper from one of the local fire departments in either Adair or Taylor County. This photograph offers a good perspective of the flow of water that is released from the dam to maintain the elevation of water in the lake. (Larry Smith)

In 1969, Jack Davis flew over the newly completed 144-foot-high Green River Dam as it was beginning to back up water. At full pool, the reservoir contains 8,860 surface acres of water. The dam is the largest in the Louisville District of the US Army Corps of Engineers and the dam and lake construction was authorized by the Flood Control Act of 1938 at a cost of $33.4 million. Below, Jack Davis operates a boat with sisters Fannie and Leona Davis around 1968. The US Army Corps of Engineers had completed work on the dam, and prior to impoundment, crews were in the process of removing remaining structures when heavy rain stopped work. The Davis family made one more trip to see their home before it was inundated by the lake. (Both, Betty Gorin.)

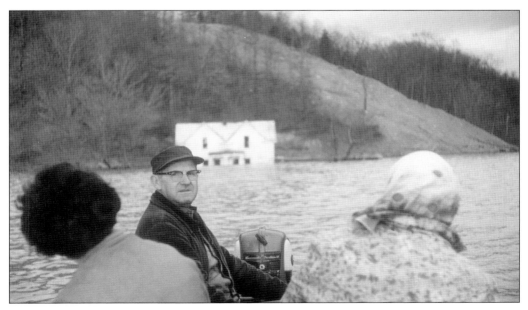

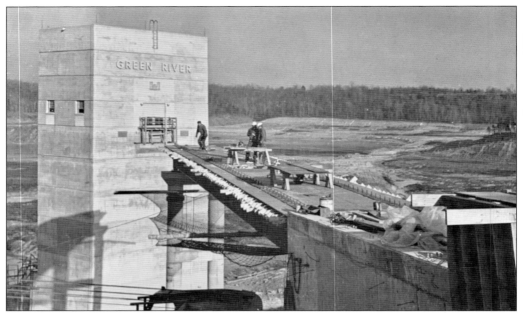

This image shows construction of the dam's control tower on Green River Lake in the late 1960s. Water levels and weather reports are monitored each day in order to anticipate water reaching or exceeding the storage capacity of the lake. Once it was functional, the control tower housed the gates that US Army Corps of Engineers staff use to control water outflow from the dam. (US Army Corps of Engineers.)

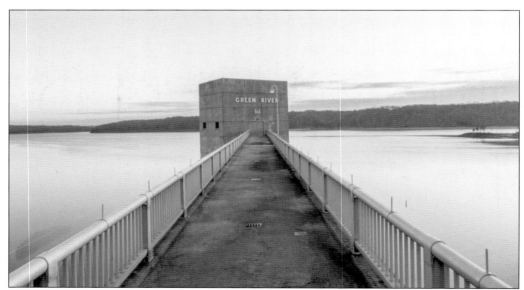

The completed control tower also shows Green River Lake at full pool sometime during the summer. Each October, the lake is drawn down in anticipation of heavy winter rains. The primary mission of the Green River Lake Project is to ensure that downstream flooding is minimized while also providing recreation and municipal water supplies for the local area. (US Army Corps of Engineers.)

The 1840 Atkinson-Griffin House was on the Campbellsville–Columbia Turnpike and served as a Confederate hospital after the Battle of Tebbs Bend on July 4, 1863. This is where Confederate general John Hunt Morgan began his raid into Indiana and Ohio. The battle raged for three and a half hours between three Confederate cavalry regiments and five companies of the 25th Michigan Infantry at Green River. (Photograph by Richard Hines.)

The Green River National Wildlife Refuge was dedicated in 2019 in Henderson County and will be managed by the US Fish and Wildlife Service to protect bottomland forests and migratory birds along the Green and Ohio Rivers. From left to right are Margret Everson, director of the Fish and Wildlife Service; Sen. Mitch McConnell; David Bernhardt, secretary of the interior; and Rep. James Comer. (Stacy Hayden.)

Today, the upper Green River is a destination for outdoor recreation. Numerous canoe rentals have developed as well as public boat launching points. Pictured here are Scott Jordon (left) and Stan Allen from Hays, Kansas. For years, these two anglers made annual trips fishing for smallmouth bass near Mammoth Cave. They are among thousands of anglers who fish and float Kentucky's Green River each year. (Photograph by Richard Hines.)

Singer-songwriter John Prine made Paradise, the Green River, and Rochester Dam famous in his song "Paradise." In the last verse, he sings, "When I die, let my ashes float down the Green River . . . let my soul roll on up to Rochester Dam." After his death in 2020, half of his ashes were scattered in the river above Rochester Dam. John Prine Memorial Park was dedicated in 2022. (Photograph by Richard Hines.)

Shawn Hines is shown fishing below the remains of the original structure of Lock and Dam 4 at Woodbury. The view upriver shows where the old dam washed out in 1965, and over 60 years of accumulating sediment is stacked in front of the lock gate. The lock chamber and walls remain as a testament to the engineers who built this structure in 1838. (Photograph by Richard Hines.)

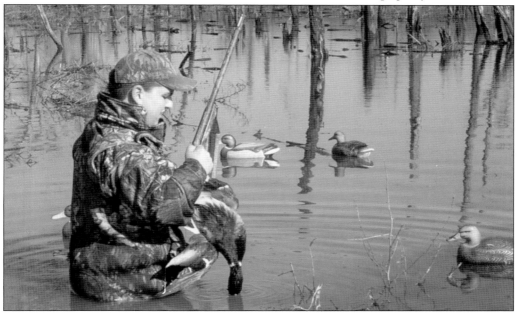

Hunting remains popular, and Kentucky currently has three wildlife management areas on the Green River—Sloughs, Peabody, and Green River. Managed by the Kentucky Department of Fish and Wildlife, these areas manage habitat and provide public hunting opportunities. Here, Josh Hines has harvested a mallard shot in a beaver pond at Green River WMA in Adair County. (Photograph by Richard Hines.)

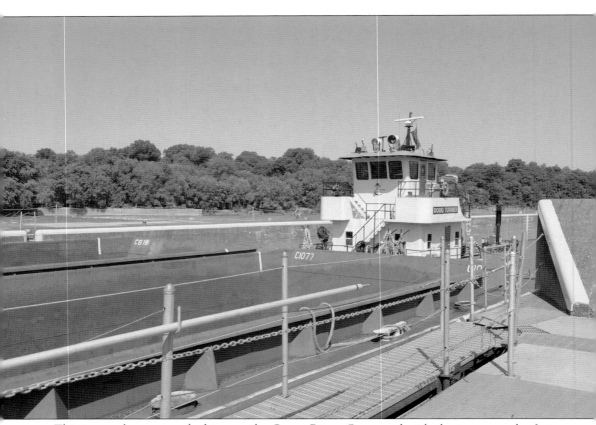

This image shows a tow locking on the Green River. Compared with the image on the facing page, this photograph illustrates how the river changes over its 384-mile journey across Kentucky. The tow *Doug Turner*, owned by the Crounse Corporation, was upbound with four empty barges. Crounse maintains a fleet of 37 towboats and over 1,100 barges that operate throughout the Ohio/Tennessee River system. (US Army Corps of Engineers.)

Richard Hines is standing in the Green River in Lincoln County near Kings Mountain only a quarter mile downstream from the source. At this point, the river is only an order 1 stream or what many refer to as a "wet weather branch." (Photograph by Ed Huffman.)

Ed Huffman is pictured at the source of the Green River at Kings Mountain in Lincoln County, which is approximately 384 miles from the river's confluence with the Ohio near Henderson. Bisected by US Highway 27, three streams source within a short distance of this location—the Green River (flowing to the Ohio River), Buck Creek (flowing south to the Cumberland River), and a small creek flowing east to the Dix River. (Photograph by Richard Hines.)

BIBLIOGRAPHY

Becker, Jane S. *Selling Tradition: Appalachia and the Construction of an American Folk 1930–1940.* Chapel Hill, NC: University of North Carolina Press.,1998.

Callan, Brennan. "Green River History." www.brennancallan.com/gr.html.

Camplin, Paul. *A New History of Muhlenberg County.* Greenville, KY: Caney Station Books,1984.

Crocker, Helen Bartter. *Green River of Kentucky, The.* Lexington, KY: The University Press of Kentucky, 1976.

———. "Green River Steamboating a Cultural History, 1828-1931." Masters thesis. Western Kentucky University, 1970. digitalcommons.wku.edu/theses/1663.

Gardiner, Florence Edwards. *Cyrus Edwards' Stories of Early Days.* Louisville, KY: The Standard Printing Company, 1940.

Gorin, Betty Jane, and Jeremy Johnson. *Campbellsville, Taylor County, Kentucky: A History.* Self-published, 2019.

Greene, William P. *The Green River Country from Bowling Green to Evansville.* Bowling Green, KY: Unigraphic, 1976.

"Green River Watershed Section 729 Initial Watershed Assessment." US Army Corps of Engineers, 2011.

Harralson, Agnes S. *Steamboats on the Green, and the Colorful Men who Operated Them.* Berea, KY: Kentucky Imprints, 1981.

Hartford, Ellis Ford, and James Fuqua Hartford. *Green River Gravel.* Utica, KY: Sam McDowell's Printing, 1963.

Henderson, A. Gwynn, and Rick Burdin. "Hunters and Gatherers of the Green River Valley." Lexington, KY: Kentucky Archaeological Survey, 2006. www.kentuckyarchaeologicalsurvey.org/wp-content/uploads/2020/05/Green-River-Archaic.pdf.

"Historical Sketches of Henderson, Kentucky." Historical Records Survey, 1939. "Interim Green and Barren Rivers Navigation Reconnaissance Study, Vol. 1." US Army Corps of Engineers, 1990.

Rothert, Otto Arthur. *A History of Muhlenberg County.* Louisville, KY: John P. Morton & Co., 1913.

DISCOVER THOUSANDS OF LOCAL HISTORY BOOKS FEATURING MILLIONS OF VINTAGE IMAGES

Arcadia Publishing, the leading local history publisher in the United States, is committed to making history accessible and meaningful through publishing books that celebrate and preserve the heritage of America's people and places.

Find more books like this at
www.arcadiapublishing.com

Search for your hometown history, your old stomping grounds, and even your favorite sports team.